FRUITS

of the

EARTH

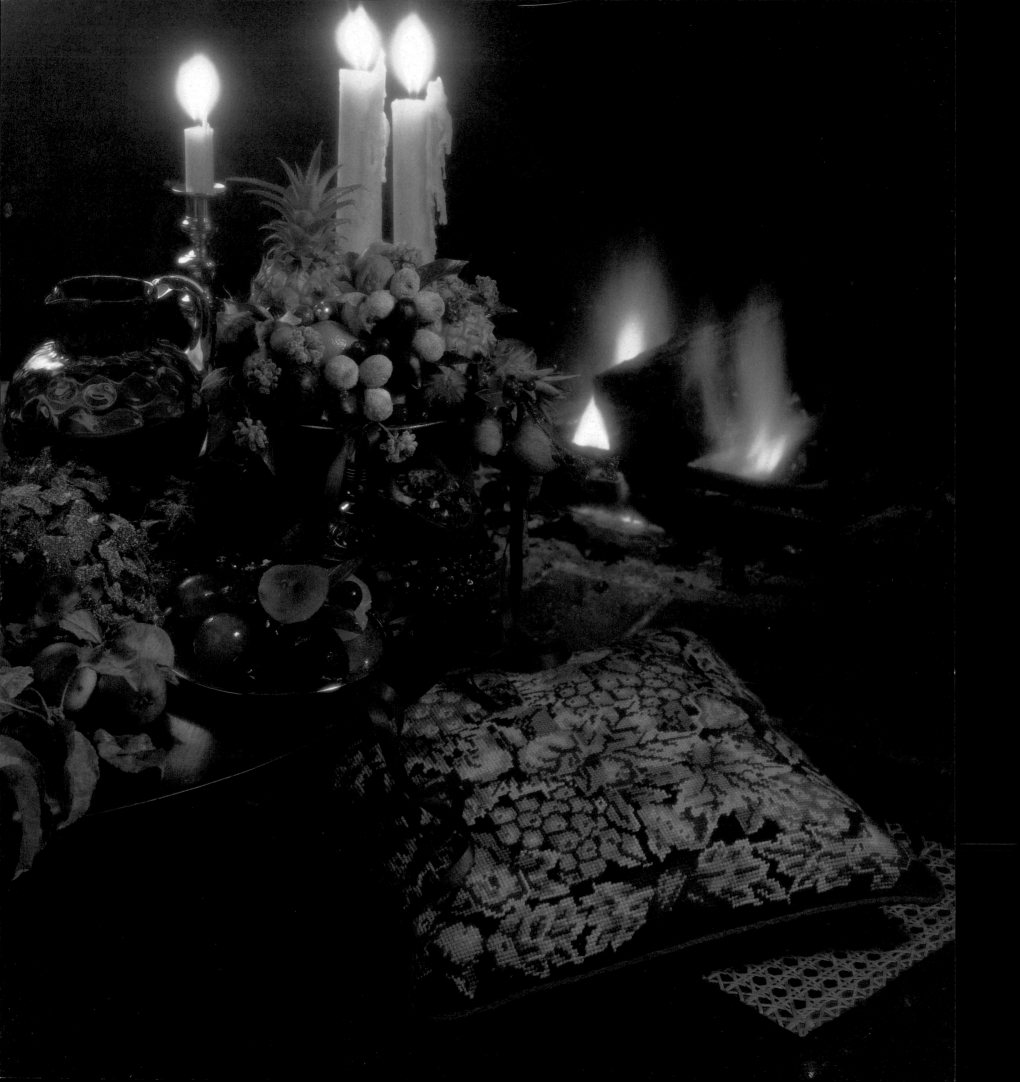

FRUITS
of the
EARTH

Flowers and Fruit in Needlepoint

HUGH EHRMAN

Photography by Rosemary Weller

SIMON AND SCHUSTER

New York London Toronto Sydney Tokyo Singapore

SIMON AND SCHUSTER
Simon & Schuster Building
Rockefeller Center
1230 Avenue of the Americas
New York, N.Y. 10020

Typeset by SX Composing Ltd, Rayleigh, Essex, U.K.
Printed and bound in Singapore

10 9 8 7 6 5 4 3 2 1

Library of Congress Cataloging in Publication Data
Fruits of the earth: flowers and fruit in needlepoint/[compiled by]
Hugh Ehrman.
p. cm.
A selection of over 40 designs from some of the best contemporary
designers.
Includes index.
ISBN 0-671-74987-0
1. Canvas embroidery—Patterns. 2. Flowers in art. 3. Fruit in
art. I. Ehrman. Hugh.
TT778.C3F78 1992
746.44'2—dc20 91-3575

CONTENTS

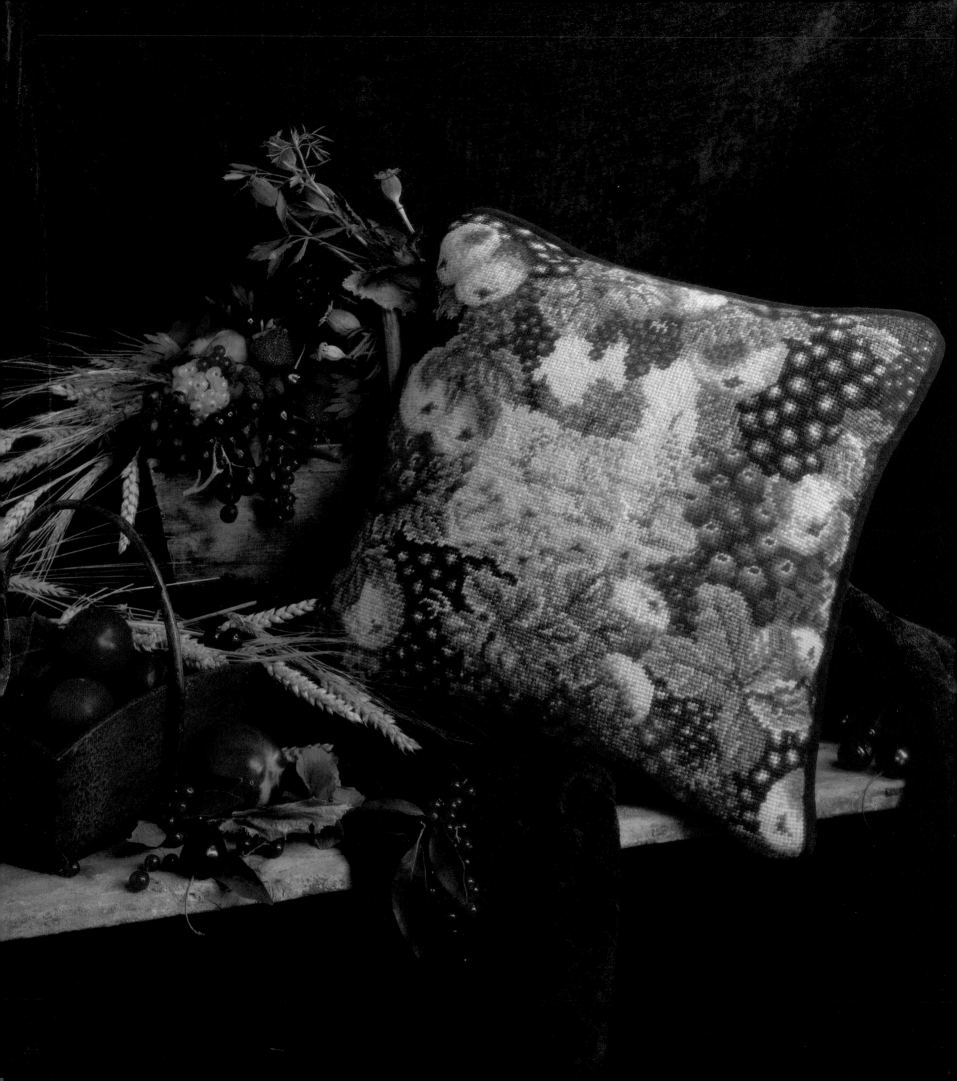

INTRODUCTION

Plant forms of one sort or another, whether leaves, flowers, fruits or vegetables, have always been the most popular source of ornamentation for the decorative arts. This has been true from the earliest times. Egyptian jewellery, Greek vase decoration, Roman murals all celebrated the colours and patterns of nature. It is just as true today. You only have to look around as you walk along the street to find yourself surrounded by floral decoration in shop window displays, on railings and lamp posts, on clothes, on buildings and on all sorts and types of packaging. But it is indoors that this fascination with depicting nature really blossoms. Paintings, china, plasterwork and, most visibly of all, carpets, curtains and upholstery fabrics have for hundreds of years feasted on the inexhaustible richness of colour, shape and pattern found in the gardens, forests and countryside beyond. So it is not surprising that the majority of our best tapestry designs deal with these matters, as nature is a literally never-ending source of inspiration to all embroiderers and textile designers.

It was difficult deciding how to group the tapestries in this book. The most obvious way would have been by subject under fruits, flowers, vegetables, leaves, etc. We chose instead to link them by theme to illustrate the different styles in such a varied collection and, hopefully, to give some insight into how the designers themselves work. This might also give people some help in selecting a tapestry to suit their own homes and Rosemary Weller's beautiful photography complements the character of each design with great skill. Once we set about dividing them in this way they fell quite easily into the six groups which act as chapter headings. Some overlap classifications. Kaffe Fassett's 'Melons', for example, would go equally well in the chapter on colour shading or the chapter on pictorial design, but that doesn't matter. The themes of the book naturally flow into each other, and grouping them was never going to be an exact science. As the company commissioning and producing these designers' kits, Ehrman is honoured to be associated with such a talented group of people. It is tremendously exciting each year to see what new direction their work is taking and this book pulls together, to my mind, some of their very best examples. There are fourteen designers represented here, twelve of whom work in Britain. It is a testimony to the deep-rooted tradition of canvaswork embroidery in this country that there is so much artistic interest in it at present; and it is wonderful that so many young designers are, once again, working in this field.

You will notice I have just used the term: canvaswork embroidery. That is the correct description of this type of stitching but it is more commonly known by its 'slang' term: tapestry. To confuse matters further, tapestry is really woven tapestry – nothing to do with stitching canvas. We cannot, unfortunately, change the common usage of the English language. If the majority of people refer to our kits as tapestry kits we will too. So I hope that clears up an understandable confusion. The problem over terminology was the fault of the Victorians. The term tapestry was then used to describe certain types of Berlin woolwork because it echoed the feel of medieval woven tapestries. The description stuck and has persisted ever since. We all know what we are talking about now but it is best to spell it out to avoid being accused of ignorance by the purists! Many of the designs in this book have been charted and nearly all are available as kits. For those of you who design your own tapestries I hope this small selection of work from other contemporary textile artists will provide a few ideas. I hope it will encourage everyone to take a fresh look at the astonishingly beautiful shapes and colours found in the natural world.

Hugh Ehrman
February 1991

DECORATIVE AND ORNAMENTAL

Decorative, ornamental, rich and traditional are adjectives that describe this group of tapestries. Patterns and styles of old fabrics, chintzes, damasks and woven tapestries provide the background material. With the exception of Kaffe Fassett's 'Christmas Fruit', there is also a conscious attempt to recapture the faded, subdued tones of the originals. The majority of designs in this chapter are by Margaret Murton who started to work with wool only three years ago, which should act as an inspiration to us all.

For many years Margaret Murton has painted furniture and wooden panels and an example of her work was featured in *The World of Interiors* magazine which I saw by pure chance. It was a repeating floral pattern, painted on one of her wooden panels in dusty 'antique' colours and it struck me that this could translate very well into a tapestry. I planned to get in touch with her. To my amazement, two or three days later she rang to introduce herself and to say that she had seen our catalogue and would be very interested in designing tapestries for Ehrman! Such telepathic contact had to be preordained, and it was clear we were going to work together. However, there was no guarantee that a painter of soft watercolour washes would be able to achieve the same effect in wools. Softening the contrasts and blending the tones of wools is an acquired skill. But, with her first tapestry design it was apparent that she had a natural affinity for working in this medium and over the last three years she has produced a further twelve designs for us, including a seven-foot carpet.

As a company Ehrman has always tried to interest designers from other fields to try their hand at tapestry and they have often come to us. I originally started in business with my brother Richard and, along with our tapestry kits, we ran a shop/gallery specialising in modern craft design from silversmithing to ceramics. In the late 1970s Britain was undergoing a renaissance in this field and we were lucky enough to sell the work of some outstanding designers: ceramics by Alison Britton, Jacqueline Poncelet and Gordon Baldwin; jewellery by Mick Milligan, David Courts and Bill Hackett; silver by

Robert Marsden and Michael Lloyd and textiles by Kaffe Fassett and Lillian Delevoryas among many others. It was an era when designers experimented in different fields; the most obvious example being Kaffe Fassett who was designing knitwear for Bill Gibb and Missoni, fabrics for Designers Guild and tapestries for us. Most students, however, coming out of art college were inhibited from trying anything outside their subjects and the courses at art colleges discouraged cross-fertilisation of ideas. It has always struck me that a really talented designer can operate in a number of fields, and should have the ambition to do so. So Ehrman always encourages artists from other disciplines to experiment with tapestry design and sometimes it pays handsome dividends. Three of our new designers come from different disciplines: Alison Hoblyn is an illustrator and textile designer; Edwin Belchamber is a graphic artist; and Candace Bahouth is a weaver. A successful transition from one medium to another is not, however, guaranteed. Painting with wools and understanding the subtle colour gradations of tapestry takes a very good eye and a feel for the materials; and often a beautiful design is spoilt by crude colouring. Working with artists from other sources has, however, injected a new design element into the world of needlework and I hope it is one which will continue. At the end of the day experimenting with new ideas for design is what makes it fun, and, despite the occasional disaster, has produced some stunning results.

'Harvest Wallhanging', 'Cascade of Fruit', 'Goblet of Fruit' and the 'Blue Ribbon Carpet' by Margaret Murton can be seen as a group. You can mix any combination in a room and they will blend together beautifully. Ochre and sandy yellows, biscuit and tawny browns, dusty pinks and off-whites are set against a deep midnight blue in all four designs and these colours also predominate in the darker colourway of the 'English Damask Chairseat'. The 'Harvest Wallhanging' and 'Goblet of Fruit Firescreen' are composed classical designs within borders, while the other three resemble sections from old tapestries or textiles. There was a vogue in interior decoration

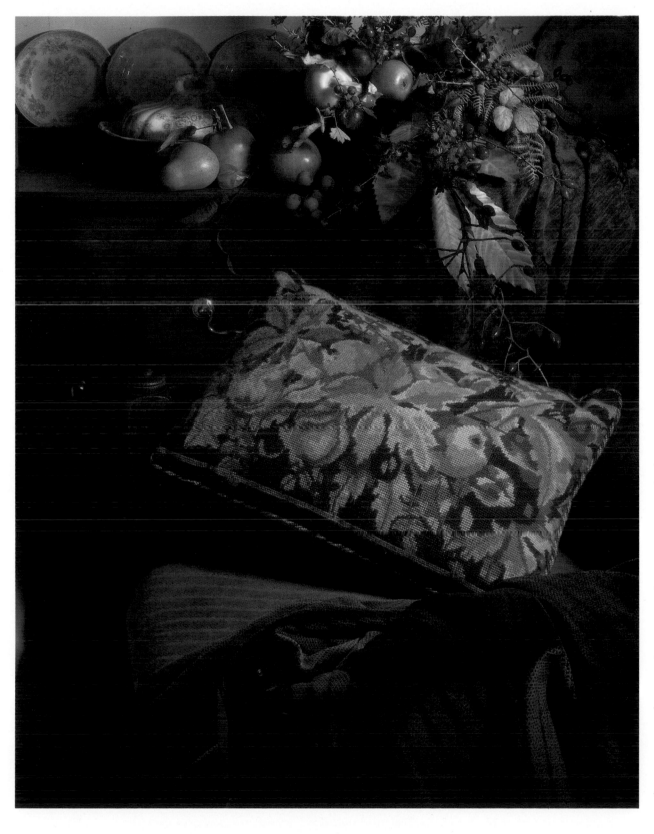

'Cascade of Fruit' by Margaret Murton (left). *The colours and composition of this long cushion cover are reminiscent of a section of border taken from a European woven tapestry. These richly decorative borders often featured fruits and leaves tumbling in profusion from corner to corner. Borders were rarely seen on tapestries, except on those from Germany, until the beginning of the sixteenth century. They then began to play a very important part in the general effect, and the best artists of the day were called in to design them. Many beautiful and varied pieces of work were produced, especially in the sixteenth and seventeenth centuries, and by the eighteenth century they often featured lush confections of drapery and flowers. These borders are endless sources of all-over pattern and, if they do not feature classical motifs and scenes, nearly always feature vegetables, flowers, fruits and leaves in some form or other.*

CASCADE OF FRUIT
by Margaret Murton

For many years Margaret Murton has painted furniture and wooden panels. She started to work with wool only three years ago, which should act as an inspiration to us all. There is no guarantee that a painter of soft water-colour washes would be able to achieve the same effect in wools. Softening the contrasts and blending the tones of wools is an acquired skill. But, with her first tapestry design it was apparent that she had a natural affinity for working in this medium.

MATERIALS

Tapestry wool (see Colourways). The amounts given are for tapestry wool worked in basketweave or continental tent stitch. If the design is worked in half-cross stitch, 30 per cent less wool is required. Double-thread or interlock canvas is suitable for all three types of tent stitch, but if basketweave or continental tent is used an ordinary mono canvas may be substituted. Two strands of Persian wool or three strands of crewel can be substituted for the single strand of tapestry wool used here (see page 113).

12-mesh double or mono interlock canvas 55cm by 40cm (22in by 16in)
Size 18 tapestry needle
55cm (22in) furnishing fabric for backing
1.7m (2yd) narrow piping cord
Cushion pad (pillow form) 46cm by 31cm (18in by 12in)
33cm (14in) zip fastener (optional)
Scroll or stretcher frame (optional)
Tools and materials for preparing canvas (see page 114) and for blocking (page 115)

The finished cushion measures 46cm by 31cm (18in by 12in) and is worked on 12-mesh canvas.

WORKING THE EMBROIDERY

Prepare the canvas and mount it on the embroidery frame, if used (see pages 114 and 115).

Following the chart on the right and using a single strand of tapestry wool, work the design in basket-weave or continental tent stitch, or in half-cross stitch.

BLOCKING AND MAKING UP

Block the completed work (see page 115) and allow it to dry thoroughly. Trim the canvas edges, leaving margins of 2cm (¾in).

From the backing fabric cut a piece 50cm by 35cm (19½in by 13½in). Or, if inserting a zip, cut two pieces as specified on page 116.

From the remaining fabric, cut and join bias strips to cover the piping cord (see page 117). Make up the piping.

If using a zip, insert it in the back cover (see page 116).

Attach the piping to the back cover as described on page 117.

Join the front and back covers as described on page 117, and insert the cushion pad.

COLOURWAYS AND YARN AMOUNTS

The cushion cover pictured was worked in Appleton tapestry wool. DMC tapestry wool colours are given as an alternative; you should note, however, that colours in an alternative brand of yarn will only provide approximate equivalents.

- 12m (13yd) of Appleton 935 (or DMC 7372)
- 14m (15yd) of Appleton 128 (or DMC 7449)
- 8m (8yd) of Appleton 209 (or DMC 7448)
- 8m (8yd) of Appleton 207 (or DMC 7447)
- 12m (13yd) of Appleton 767 (or DMC 7459)
- 27m (29yd) of Appleton 765 (or DMC 7780)
- 41m (44yd) of Appleton 763 (or DMC 7421)
- 43m (47yd) of Appleton 761 (or DMC 7511)
- 26m (28yd) of Appleton 976 (or DMC 7527)
- 41m (44yd) of Appleton 974 (or DMC 7416)
- 41m (44yd) of Appleton 972 (or DMC 7415)
- 76m (83yd) of Appleton 328 (or DMC 7289)

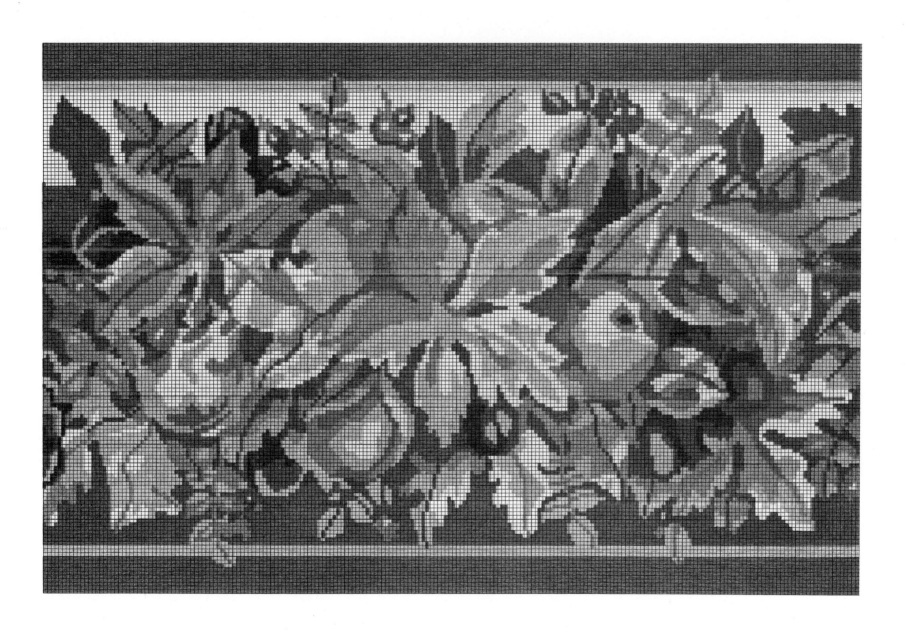

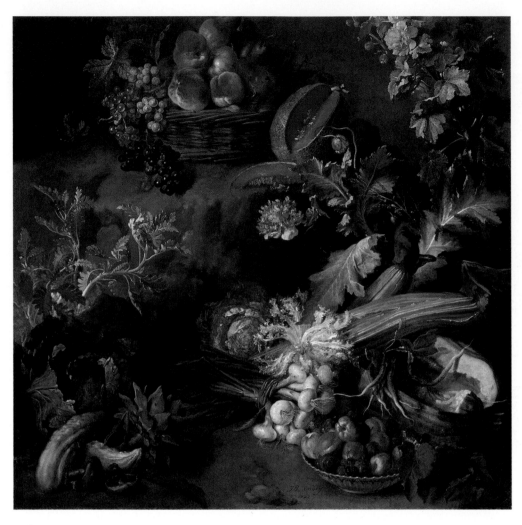

Nothing ages more beautifully than textiles and, in particular, wools. The faded tones of woven tapestries or embroideries are half their appeal, and the soft washes of deep viridian, indigo and silvery greys that you see again and again in seventeenth- and eighteenth-century tapestries must originally have been quite strong and sharp. Textile conservationists are now very aware of the damaging effect of sunlight. Even some of the early kit samples in our shop in London look quite faded after five or six years. But I must admit to a preference for the bleached colours of older textiles over the brighter colours they were originally intended to be. Both Kaffe Fassett and Margaret Murton are able to capture these softer shades in their work, which is a great achievement when working with a palette of new wools and it is the true test of a skilled colourist. Kaffe Fassett's 'Harvest Bowl' on page 18 is a perfect example.

There is a limit to the number of cushions anyone can want, and two or three years ago we found an increasing demand from our customers for other items to stitch. This gave us the opportunity to embark on larger projects, the biggest of all being Kaffe Fassett's 'Apple and Cabbage Carpet', shown on page 99. It also allowed the designers much greater scope to expand their more complex and adventurous ideas. It coincided with a general revival of interest in decorative textiles. Kelims and embroideries started appearing on walls, as well as on floors, and prices for all types of textiles rocketed in the salerooms. The fashion for Victorian needlework carpets and Victorian floral cushions has perhaps peaked but the hunger for wallhangings and carpets is certainly here to stay. Tapestries look marvellous on the wall, after all it's how they were originally hung, and particularly on stone, wood or plain painted walls. Elian McCready's 'Pansies Panel', on page 72, with its strong glow of colour and bold outlines, looks superb on a plain white wall in a modern flat. Small panels can fill up odd corners or warm up passages or kitchens and an increasing number of our designs are used in that way. The 'Harvest Wallhanging' shown on page 15 is probably better suited to a more formal

Detail from Earth (The Four Elements) *by Jean-Baptiste Oudry* (above) , *1721, which is painted on panels over a door in the Royal Palace in Stockholm, Sweden. It is a great shame that Scandinavia is so expensive as the cost of visiting these countries acts as a serious deterrent. Stockholm, which is largely unknown to British travellers, is one of Europe's finest eighteenth-century cities with the old medieval town preserved largely intact. It is a lovely city, full of treasures, which is well worth visiting.*

recently for cutting up old textiles to make cushions. They looked lovely but it always seemed a waste to destroy old textiles in this way, so Margaret decided to create a series of designs to replicate textile fragments which people could stitch themselves. If you are looking for ideas to create your own designs you'll find that taking sections wholesale from old fabrics can yield an infinite number of images. The borders of Flemish or Mortlake woven tapestries contain endless sections that can be transferred directly on to a printed or painted canvas. Often a section like this is improved by a slight rearrangement of motifs or the addition of a border but sometimes it can work just as well reproduced unaltered. The skill then lies in capturing the colours.

setting, and it is a manageable and useful size, only 760×760mm (2½-foot square).

Many of the larger tapestries can be used in different ways. The 'Goblet of Fruit' photographed as a firescreen above would work equally well as a small wallhanging and the dark colourway of 'English Damask', shown above as a cushion, was originally designed as a chairseat. The only general caveat is to check the gauge of canvas. All of our chairseat covers are on 10 holes to the inch canvas, as 12 would wear quickly; rugs or carpets intended for the floor should really be on 8-mesh canvas or wider. The majority of our rugs are on 7-mesh canvas using tapestry wool stitched double. This gives a perfectly durable texture and makes them reasonably speedy to stitch. Cross

stitch will give a more hardwearing texture to the rug but, as always, it is a matter of degree. A number of our cushions are now worked, like the rugs, in half-cross stitch with doubled-up wool on 7-mesh canvas. This was Kaffe Fassett's innovation and has proved very popular as stitching time is almost halved. It is, of course, much more satisfying to watch something grow quickly and it is astonishing how much detail and colour variation a good designer can incorporate into a cushion cover worked on this wide gauge of canvas.

The number and variety of rugs available as kits has expanded dramatically in recent years. There are some lovely rug kits on the market today from companies such as Glorafilia and Elizabeth Bradley, as

These three designs by Margaret Murton (above) go well together. The 'Goblet of Fruit' on the left was designed as a firescreen, the central cushion was originally a chairseat cover while the 'Harvest Wallhanging' on the right has been photographed to show its intended use. These types of designs, with their strong resemblance to fabrics, can have a multi-purpose role, the muted colour ranges working well in a wide variety of rooms.

Margaret Murton's 'Blue Ribbon Carpet' (right) would have gone equally well in the chapter on 'Pattern Repeats'. A strip of design has been repeated and then reproduced in stripes. A fringe in cream wool or silk could be added at each end to finish it off. Margaret's original instructions specified dimensions, colours, etc. but she only provided artwork for the strip which was to be repeated. This was very sensible. The repetitive and laborious work of multiplying the design to form the repeat pattern was done by computer. New technology such as this is being used increasingly for artwork and origination of all types. It is obviously best suited to labour-saving tasks such as repeat patterns as even the most advanced computer could not produce truly creative design; but it is a very useful addition to the array of tools available to the designer and will be used more and more in the future by artists of all kinds.

In the paler colourway of her 'English Damask' chairseat cover (opposite page) Margaret Murton goes for softer, more faded tones. This design would also make a good cushion, particularly if edged with piping.

well as our own, and stitched carpets are now far more popular than handtufted ones. Persian carpets have never gone out of fashion nor have Aubusson rugs but their price puts them beyond the reach of most people. So we asked Margaret Murton to produce a small carpet with a very traditional feel in muted colours that would go with traditional furnishings and antique furniture. You can see the result above. She has used a simple flower and ribbon repeat pattern to great effect in stripes. This design could be extended to make a much larger carpet if required but we are limited by the practicalities of producing a manageable canvas size. It is probably easier to work a canvas of this size on a floor-standing frame, being such a large and weighty object, but it is not essential. Printing a canvas of these dimensions is a complicated business. It is hand-printed with a series of cut stencils and preparing the artwork for a carpet like this and working out the wool quantities can take up to six months. So we do not produce more than two or three kits of this size a year.

The last of Margaret Murton's designs in this chapter is 'English Damask Chairseat' on page 17 in the navy and sage colourways. Again it gives the impression of being a section of fabric or tapestry and this is particularly appropriate for a chairseat. Because of the irregular shapes of chairs, chairseat designs tend to have a central pattern surrounded by acres of flat monotone background colour. But in producing an all-over pattern scale is vital. The design is printed to an all-over size of 505×505mm (20in square) which will cover almost any chairseat. The design will then be cut into to fit the contour of the seat. If the motifs are on too large a scale the overall pattern will lose focus when cut into in this way and look very strange. If the motifs are too small the design will look fussy and lose the flowing feel of tapestry. The 'English Damask' pattern gets it right and the soft tones of the sage colourway, on its oatmeal background, capture the faded feel of an old tapestry.

Kaffe Fassett is the best-known name in needlework design and is probably the only name recognised by those who are unfamiliar with the subject. A good-looking man, with a name that no one can pronounce, who knits on television with his socks off is bound to cause some interest! But he is not known simply for these reasons. There is a growing public awareness that in the sleepy world of knitting and needlework design a rare talent is at work of an artistic significance not normally associated with these activities.

I remember meeting Kaffe for the first time in 1976 with Bill Gibb and watching them make the final selection for Bill Gibb's next fashion show. I was working for *Vogue* magazine at the time and was photographing Bill Gibb's flat. Norman Parkinson, the photographer, was late so I was given a large selection of *National Geographics* to read while waiting. In this spare half hour I was able to watch the two at work and I realised what an extremely forceful personality Kaffe Fassett was and how clear a vision of his work he had. It is this vision, and his determination to share it with a wider audience, which marks Kaffe out from many other designers.

Kaffe Fassett has made his name as a knitter and stitcher and throughout the 1980s this has been his principal activity. Surprisingly few people are aware of his achievements in the 1970s when his work was known to a smaller but intensely loyal group of admirers. Along with Lillian Delevoryas, he was instrumental in creating the look for Designers Guild, the fabric and wallpaper business run by Tricia Guild. In the early days it was very strongly influenced by Kaffe's style and he still designs fabrics for them. He designed all the knitwear collections for Bill Gibb and acted as both a colourist and designer for Missoni of Italy. Without a doubt Kaffe's colours were the most significant aspect of Missoni's look in the late 1970s and early 1980s. So his design influence was pervasive before his own fame grew as a knitter and stitcher. It is his continuing involvement in a wider world which gives his tapestry design a broader sweep as Kaffe brings fresh and exciting ideas from outside to his large canvaswork commissions and kits.

The astonishing thing about Kaffe's tapestry design is the wide variety of styles he employs. Who would believe that the same designer had produced the 'Tropical Flowers' on page 86, with its iridescent sweeps of electric, abstract colour, and the 'Apple' cushions on page 97, with their structured compositions and meticulously detailed coloured shading? Who else would use such an eclectic range of source materials, from fruits to lichen patterns, turtles to lizards, and Chinese pots to cabbages? Yet, despite this massive diffusion of style and content, all his designs retain an indefinable Kaffe Fassett stamp. And that is his unique use of colour. Like all artists he goes through colour phases. I remember when yellow was banned; in the early 1980s we saw a series of soft, delicate pastels; in the later 1980s strong, vibrant colours predominated. Throughout all these changes, one constant remains – his quite unexpected colour combinations.

In this chapter there are two very different tapestries both from the mid-1980s which illustrate this range of colour and style: 'Harvest Bowl' and 'Christmas Fruit'. The colours of 'Harvest Bowl' blend well

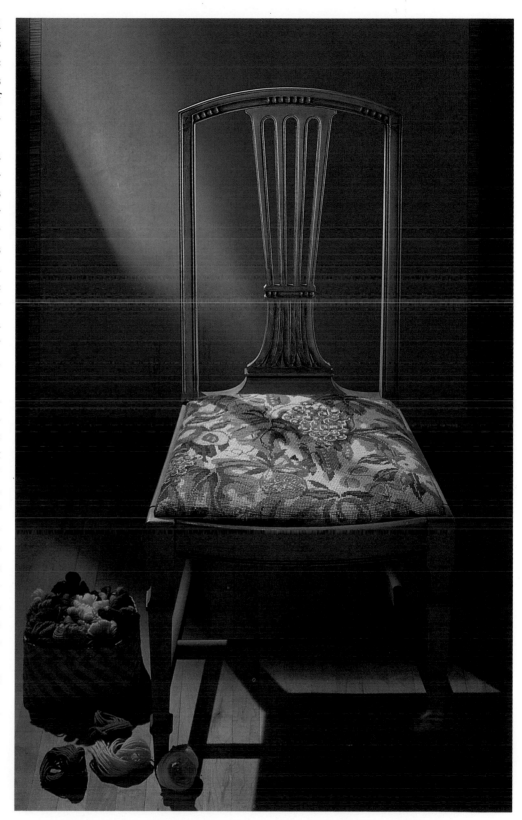

with most of Margaret Murton's tapestries featured in this chapter. They are the colours of eighteenth-century woven tapestries, predominantly deep blues and soft parchments. The idea was taken from a section of old tapestry, rearranged and recoloured in Kaffe's style, but retaining the faded, slightly rough look of the original. It was the first design in which he started to use dots of colour to build up an effect of shading. You can see this on the left-hand side of the bowl itself and in the fruits. This is one of Kaffe's unique contributions, which we can look at in more detail in chapter 6. In the large wallhangings which he works for individual commissions up to 200 or 300 shades of colour are used. As you can imagine, these are masterpieces of subtle colour gradation but until quite recently we never printed on canvas with more than fifteen colours. For years the prophet of glorious and infinite colour had to work with us under these restrictions; it was a miracle he stayed with us at all! He finally rebelled with the publication of his bestselling book *Glorious Needlepoint* and forced us to reexamine our production methods. The more colours that are used the more expensive the kit, but it is technically possible to print up to twenty-five or more colours. The 'Victorian Cats' design which first appeared in that book was later modified and printed using twenty-seven colours. With this development the floodgates were opened and Kaffe's true mastery of colour could really be appreciated. This was most noticeable with his subsequent fruit designs and some of his farmyard animals. 'Harvest Bowl' is an interesting forerunner as Kaffe achieved the soft shadings and changes of tones with a very limited range of wools.

'Christmas Fruit' marked the start of Kaffe's fascination with brighter, less naturalistic colours that eventually culminated in 'Tropical Flowers' seen on page 86. His work had been associated for many years with soft, pastel shades, always unusual and original, but well mannered on the whole. His switch to bright, iridescent and often clashing tones came as a shock to many, but once again he led the field. 'Christmas Fruit' saw the first use of acidic yellow

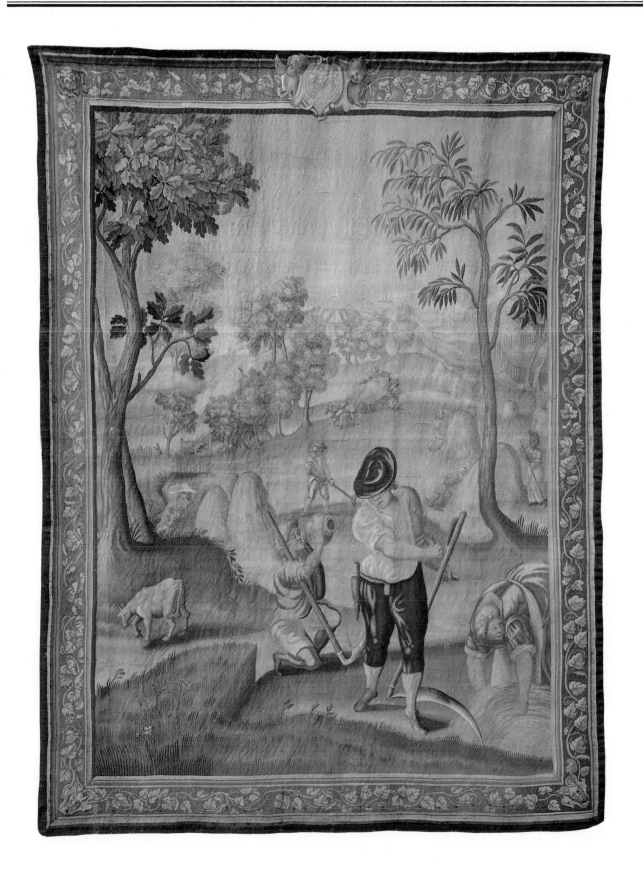

Haymaking in the Month of July. *This English Mortlake tapestry* (left), *dating from the last quarter of the seventeenth century, can be seen at the Victoria and Albert Museum, London. The Mortlake Tapestry Factory reached its peak between 1625 and 1635 when, under the patronage of Charles I, it produced the best tapestries in Europe. The Gobelins works in France had not yet been set up and, during that period, there was no rival to Mortlake. Designers included Rubens and Van Dyck and sets of tapestry panels were ordered from Mortlake by royal courts throughout Europe.*

'Harvest Bowl' by Kaffe Fassett (opposite page) *is one of his classic designs that will not date in a hurry. He has taken the rich abundance of fruits and leaves found in many eighteenth-century woven tapestries and stitched them in two broad colour ranges: sepias and blues. There is a similarity in style between 'Harvest Bowl' and Margaret Murton's 'Cascade of Fruit' on page 11. Both draw on the same sources for inspiration but are given a very different treatment by the two designers.*

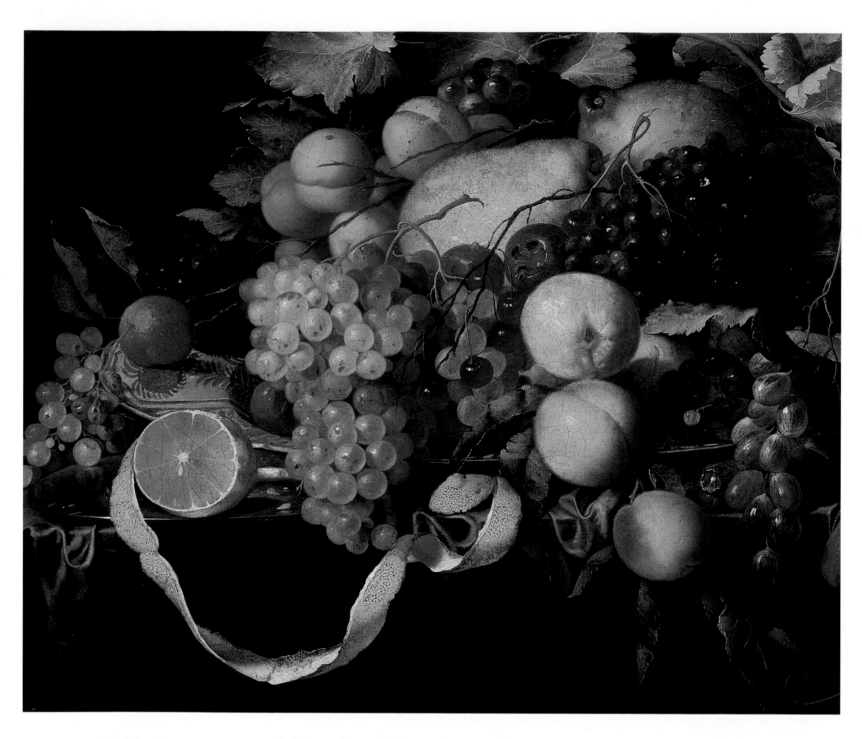

A detail from Still Life with Fruit and a Lobster (above) *by Jan Davidsz de Heem.*
'Christmas Fruit' by Kaffe Fassett (opposite page).

greens and bright scarlets and it has an American feel to it. Kaffe's brighter, fresher colours are particularly popular in the States and his following in America is now even larger than in Britain. I love 'Christmas Fruit'. I think it is still one of his very best designs with its unusual colours contained in its fairly traditional all-over pattern and formal border. It makes a most versatile cushion and with only slight adaptation could be repeated in squares to stitch together to form a colourful rug.

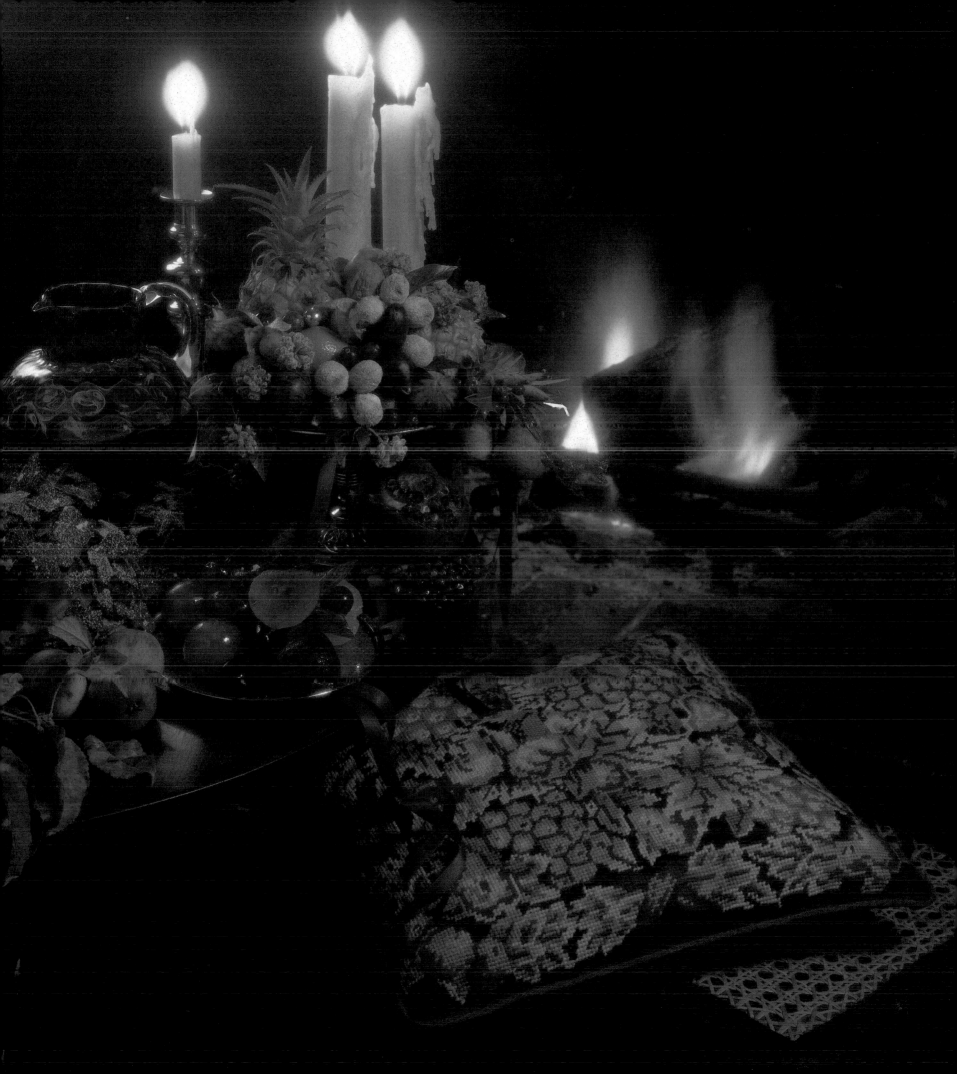

CHRISTMAS FRUIT
by Kaffe Fassett

The astonishing thing about Kaffe Fassett's tapestry design is the wide variety of styles he employs. Who else would use such an eclectic range of source materials, from fruits to lichen patterns, turtles to lizards, and Chinese pots to cabbages? Yet, despite this massive diffusion of style and content, all his designs retain an indefinable Kaffe Fassett stamp. And that is his unique use of colour.

MATERIALS
Lightweight double knitting (or, in U.S., heavy sport-weight knitting yarn), which is a tapestry wool weight (see Colourways). The amounts given are for tapestry wool worked in basketweave or continental tent stitch. If the design is worked in half-cross stitch, 30 per cent less wool is required. Double-thread or interlock canvas is suitable for all three types of tent stitch, but if basketweave or continental tent is used an ordinary mono canvas may be substituted. Three strands of Persian wool or four strands of crewel can be substituted for the single strand of tapestry wool used for this design. (To calculate amounts for crewel or Persian wool see page 113.)
10-mesh double or mono interlock canvas 50cm (20in) square
Size 18 tapestry needle
50cm (20in) furnishing fabric for backing
1.8m (2yd) narrow piping cord
Cushion pad (pillow form) 41cm (16in) square
30cm (12in) zip fastener (optional)
Scroll or stretcher frame (optional)
Tools and materials for preparing canvas (see page 114) and for blocking (page 115)

The finished cushion measures 41cm (16in) square worked on 10-mesh canvas.

WORKING THE EMBROIDERY
Prepare the canvas and mount it on the embroidery frame, if used (see pages 114 and 115).

Following the chart on the right and using a single strand of tapestry wool, work the design in basketweave or continental tent stitch, or in half-cross stitch.

BLOCKING AND MAKING UP
Block the completed work (see page 115) and allow it to dry thoroughly. Trim the canvas edges, leaving margins of 2cm (¾in).

From the backing fabric cut a piece 44cm (17½in) square. Or, if inserting a zip, cut two pieces as specified on page 116.

From the remaining fabric, cut and join bias strips to cover the piping cord (see page 117). Make up the piping.

If using a zip, insert it in the back cover (see page 116).

Attach the piping to the back cover as described on page 117.

Join the front and back covers as described on page 117, and insert the cushion pad.

COLOURWAYS AND YARN AMOUNTS
The cushion cover pictured was worked in Rowan Lightweight Doubling Knitting (a tapestry wool weight yarn). DMC tapestry wool colours are given as an alternative; you should note, however, that colours in an alternative brand of yarn will only provide approximate equivalents.

■	5m	(6yd)	of Rowan	601	(or DMC 7209)
■	16m	(18yd)	of Rowan	67	(or DMC 7108)
■	28m	(31yd)	of Rowan	44	(or DMC 7666)
▨	5m	(6yd)	of Rowan	3	(or DMC 7451)
■	24m	(26yd)	of Rowan	21	(or DMC 7873)
■	19m	(21yd)	of Rowan	402	(or DMC 7173)
□	12m	(13yd)	of Rowan	6	(or DMC 7503)
■	47m	(51yd)	of Rowan	54	(or DMC 7288)
▦	27m	(29yd)	of Rowan	89	(or DMC 7598)
▨	37m	(40yd)	of Rowan	73	(or DMC 7385)
▨	29m	(32yd)	of Rowan	37	(or DMC 7547)
▨	37m	(40yd)	of Rowan	36	(or DMC 7341)
▨	25m	(27yd)	of Rowan	76	(or DMC 7772)

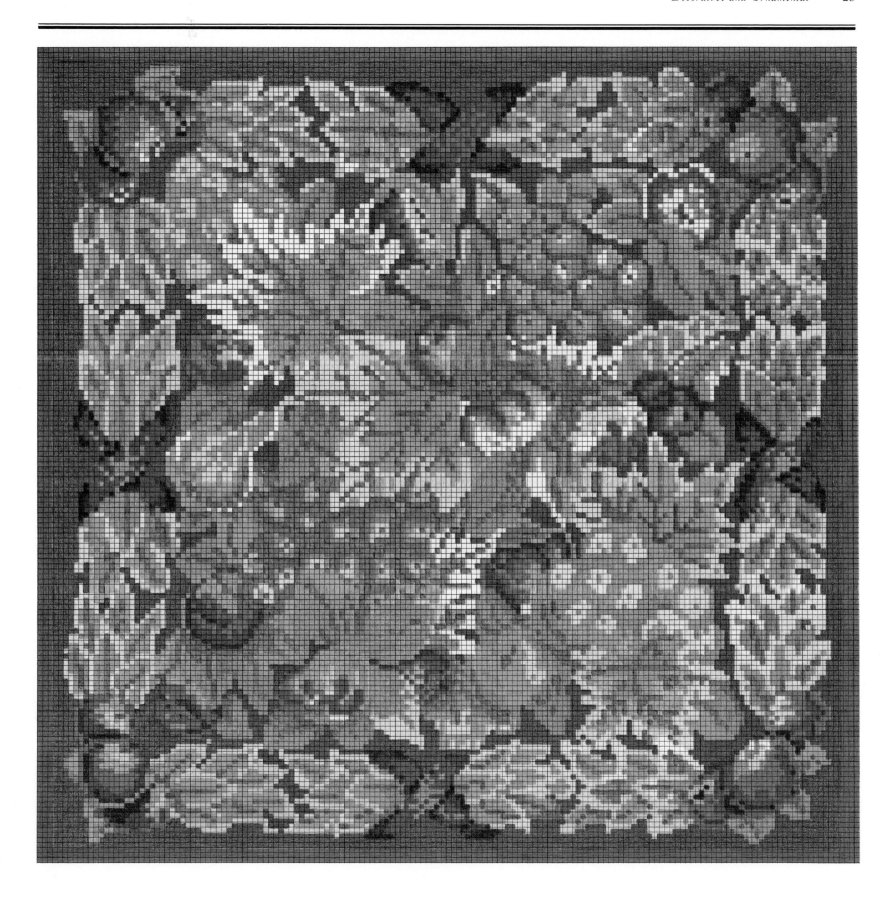

This Botanical drawing (right), *taken from a mid-nineteenth-century manuscript of flower painting in the Victoria and Albert Museum, London, is a fine example of its type. These closely observed studies of natural form provide excellent source material for needlework designers.*

Susan Skeen uses acorns and oak leaves to form the garland for her cushion (opposite page) *and combines the warm autumnal browns with the cool blues and blue greys of the geometric background. Susan Skeen has a whole series of cushions in her own house that use simple geometric patterns stitched only in shades of blues. They make very restful tapestries and could be an idea for those of you who produce your own canvaswork designs.*

Finally in this chapter we come to 'Oak Garland' designed for us by Susan Skeen. We first met Susan through the Royal School of Needlework in London. In the early days of our business we had a long and close relationship with the Royal School which was originally developed by my brother Richard. Elizabeth Pettifer was then their Principal. She was interested by our kits with Kaffe Fassett, whom she admired, and with her forward-looking ideas was keen to expand the Royal School's involvement in contemporary needlework design. Their work and design rooms in Princes Gate, opposite Hyde Park, were fascinating. The bulk of their time was split between individual commissions, often of an heraldic nature, and conservation and restoration of old textiles. Their design department was a treasure trove of work stretching back to Burne-Jones, Walter Crane and William Morris, who had all been connected with the school. Working in the design room at the time, having just left college, was Susan Skeen and she was responsible for all of our most successful Royal School of Needlework commissions. We kept

in contact when she left the Royal School and she is now designing for us again, among her many other freelance activities. In the intervening years she has worked as an editor on *The World of Interiors* and a flavour of this influence can be detected, I think, in 'Oak Garland'. Its restrained shifts of tone, in two basic colours, and its elegant but simple Regency design evokes a feel for interior decoration, and it would go well with a wide range of fabrics currently available.

'Decorative and Ornamental' may seem a rather all-encompassing title for this chapter but it captures the general flavour of this group of tapestries. They all draw for inspiration on European textiles of the past. It is almost impossible not to like the fine silks, brocades, woven tapestries, needlework and delicate embroideries that can be found in the museums of Europe. To draw on this treasury for inspiration in a creative way shows a genuine affection for these wonderful achievements of previous generations. Colours and compositions may change but certain patterns never go out of style, and these classically inspired designs will endure as they are so easy to live with and suit most people's houses. On the whole, they are consciously designed to go with older houses and furniture but it is surprising how good tapestries of this type look in simple, uncluttered rooms where they add warmth and pattern.

Just as the designs in this chapter draw on a European heritage so do those in the next, but in a very different way. They reflect a romantic tradition in European thinking which has surfaced at many periods but which is most firmly associated with Rousseau and his concept of the purity of nature. It led to romantic, sometimes mawkish, respect for the beauty of the natural world. This strand in European thinking is resurfacing at the moment with the town dweller's concept of an idealised countryside, and the general awareness of green issues. Taken to extremes, it can appear silly or excessively sentimental but, used with restraint, it can also be uplifting. It is part of an Arcadian vision of escape from the dull, colourless landscape of urban life – a pastoral idyll in a land of magic.

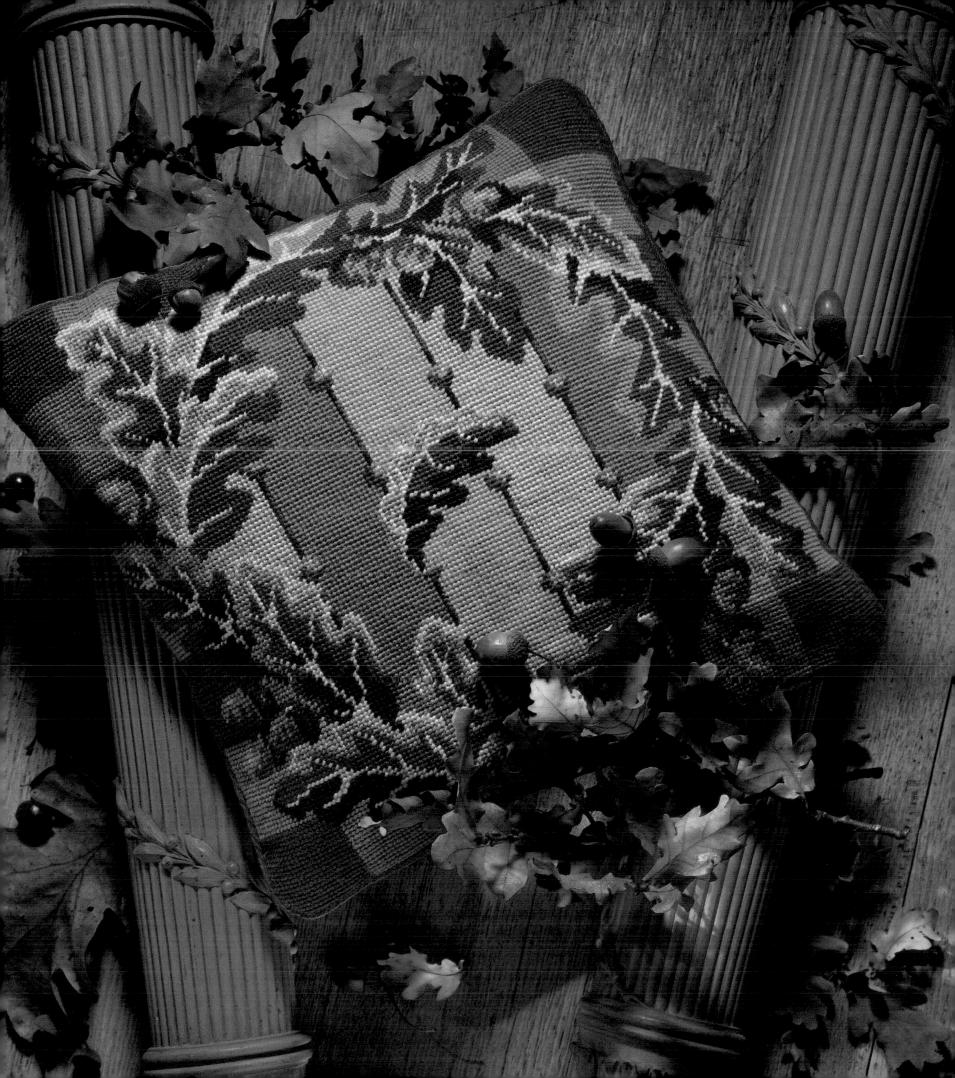

What does Arcadian mean? Very roughly it describes an idealised rural way of life, harmonious, peaceful and in tune with nature. There are no tractors, fertilisers or electric pylons in Arcadia. There are sheep and pastures, gently undulating wooded hillsides, shepherds playing pan pipes, satyrs and nymphs. At least that was the Renaissance vision of Arcadia portrayed by Giorgione or Titian; as described by Sir Philip Sidney with his idealised notions of the shepherds of Antiquity. Arcadia was actually a central plateau in Southern Greece which became synonymous to the ancient world with the purity and innocence of unspoilt, natural life. This pastoral fallacy had inspired Virgil in particular and as the West rediscovered the writings, values and arts of the classical world it seeped into the fabric of Western thinking. Shimmering leaves, shafts of sunlight, trickling water and the sound of the lute can conjure up a number of visions depending on your way of thinking: a desire for escape to a better life; a sensual humanism; a return to moral purity that predated the corrupting influences of society. You can take your pick. Its visual counterpart is a romanticised portrayal of

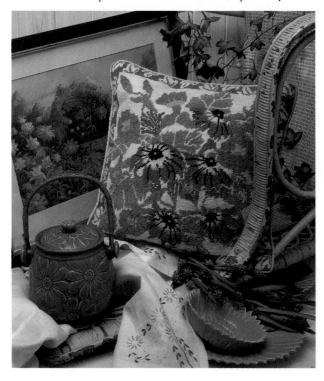

Jill Gordon's 'Blue Daisies' (right) captures the freshness of her watercolour paintings. Jill is a completely self-taught painter and the natural simplicity of her compositions, with their distorted perspective, gives her work a tremendous vitality. She paints directly from nature, not through a prism of art-school technique, and this directness is her strength.

nature: invariably unreal, often beautiful and inspired by a longing to recreate a dream. All the tapestries in this chapter are linked only by a general atmosphere: they are either wistful, romantic, magical or quirky in their approach to nature. Not a very precise link perhaps, certainly not an easy one to describe, but a unifying spirit of pastoral romanticism runs through this collection of designs.

Two designs in this chapter, 'Blue Daisies' and 'Russian Tapestry', are by Jill Gordon with whom Ehrman has worked intermittently for over ten years. In the early 1970s Kaffe Fassett and Lillian Delevoryas founded a design co-operative in Gloucestershire, called the Weatherall Workshops, which attracted many other like-minded textile designers and artists. One of these was Jill Gordon and her work has been closely linked with Kaffe Fassett's over the years. When I first visited the Weatherall Workshops, Lillian Delevoryas was producing pottery, Kaffe was painting and stitching and Jill Gordon was primarily a watercolour artist. When my brother Richard and I opened our shop in the Fulham Road, London, in 1978, one of our first exhibitions featured Jill Gordon's watercolours. This delicate, soft touch with colour is reflected in her tapestries and after such a long association with Kaffe Fassett she has developed a similar philosophy for 'painting with wool'.

'Blue Daisies' is quite an old design and is still as popular as ever. Nobody could tire of the light, cheerful colours, and the movement in the flowers brings the composition to life. I am particularly fond of the china blue and white border with its simple, rough outline of leaves. Jill manages to capture here the fluidity of her watercolours. The shading of the background leaves is effected very simply and cleverly with only two tones of green in blocks of colour and shows how much can be achieved with a limited number of colours. Although her more recent work is highly complex with lots of shading used to build a detailed perspective, this early tapestry is an excellent example of how to use a limited shade range effectively. There are no more than ten colours in 'Blue Daisies', which shows that less can often be more.

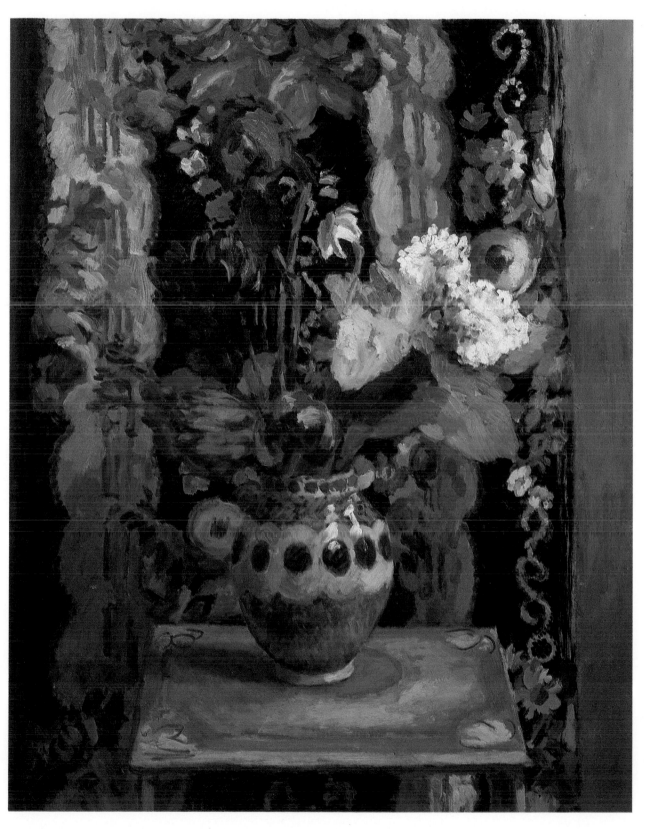

Flowers Against Chintz, *painted by Duncan Grant in 1956* (left), *is one of my favourite illustrations in this book. Duncan Grant was an outstanding colourist and he even turned his hand, now and then, to needlework. Examples of this, and needlework pieces by other Bloomsbury luminaries, can be seen at Charleston, the home of Duncan Grant and Vanessa Bell, in Sussex. They are not, however, in the same league as his murals and painted furniture, which can also be seen there, as his real talent lay with paint not wool.*

We were asked a few years ago to produce tapestry kits for the Charleston Trust which would have been exact copies of the worked pieces in the house. It was an exciting idea and we got as far as drawing up the designs for origination. It was only when we reached this stage that we realised that they would not make good kits. Their appeal lay in their rough simplicity, faded colours and harmony with their setting. Taken out of this context, printed on to canvas and stitched in new wools this fragile charm would have evaporated and reluctantly we abandoned the project. A visit to the Farmhouse, however, is highly recommended. It has an extraordinary atmosphere and is the only surviving example of the Bloomsbury Group's domestic work.

The Fruit Pickers (right). *This fan, from the Collection Esther Oldham, is now in the Museum of Fine Art, Boston. Religious persecution in France brought fanmakers to England from 1685 onwards where their trade prospered for about a hundred years. In London, studios and workshops provided work for 200 stick shapers, carvers, gilders and painters and in 1709 the London fanmakers were important enough to demand a national charter. By the time of the French Revolution, however, fans were no longer in fashion and there were no more than two entries for fanmakers in the London Post Office Directory of 1811.*

The delicacy and beauty of some of these finely painted fans is breathtaking.

'Russian Tapestry' by Jill Gordon (opposite page). *In a way this is two tapestry designs amalgamated into one. The central section could be extracted from the border to make a lovely small picture, and, next year, Jill is redesigning the border to form an all-over pattern for a chairseat cover which could be very striking. The depiction of the fruits in this border owes a lot to Kaffe Fassett's work on similar subjects. Jill has worked on a number of Kaffe's large commissioned hangings and is becoming an expert at helping to shade the fruits and vegetables which he so often includes.*

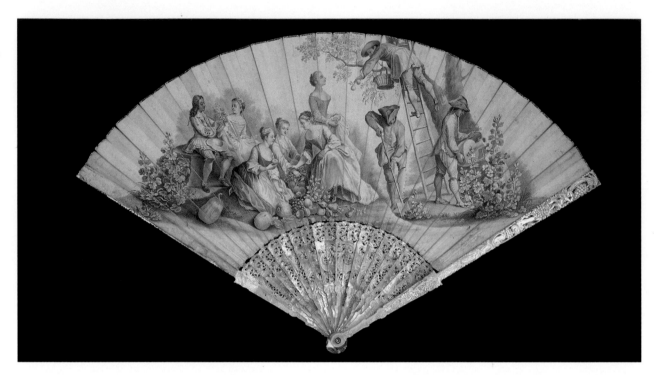

There was a gap of about five years between 'Blue Daisies' and the 'Russian Tapestry'. Jill had moved to Yugoslavia, with her children and horses, and we had lost touch. Then two years ago Kaffe told me that she was returning, full of ideas for needlework designs, and would like to produce another tapestry for us. I was delighted to be working with her again and she produced her delectable 'Russian Tapestry'. The fruits in the border are so vivid that you want to pick them up and eat them. The idea was developed from a fragment of an old woven Russian tapestry which Kaffe had spotted in a book. Jill then decided to surround the soft, pastoral landscape of the original with a rich, lush border of fruits and leaves. It gives the impression of looking into a picture. The use of colour is sensational and captures perfectly the warm, still light of a summer afternoon. Look particularly at the remarkable shading of the sky.

The design technique is quite different from 'Blue Daisies'. Recently, Jill has been working on a series of Kaffe Fassett's large commissioned works using hundreds of colours to build up complex images. She has caught his fascination with the possibilities for 'painting with yarn' by stitching dots of colour, in an almost pointillist fashion, to build a three-dimensional picture. It naturally also gives far greater scope for her choice of colours and in this design it is really worthwhile.

Not everyone will like working a design that requires so many endless changes of colour. It may seem like hard work but the complexity is only in the colour not in the stitching, which remains simple half-cross or tent stitch throughout. Not everyone will manage to align every colour exactly to the printed canvas square on a design like this. Don't worry! It doesn't matter, and is unnoticeable in the finished product. Part of the textural appeal of stitched canvaswork is its slightly uneven irregularity. So don't be put off by feeling it is impossible to replicate this picture stitch by stitch. Although you are working from a printed canvas it is not entirely stitch-by-numbers. It is the closest approximation that you wish, or are able to make, and many of our customers change colours they don't like and some have been known to alter part of the design. How far you wish to go is completely up to you.

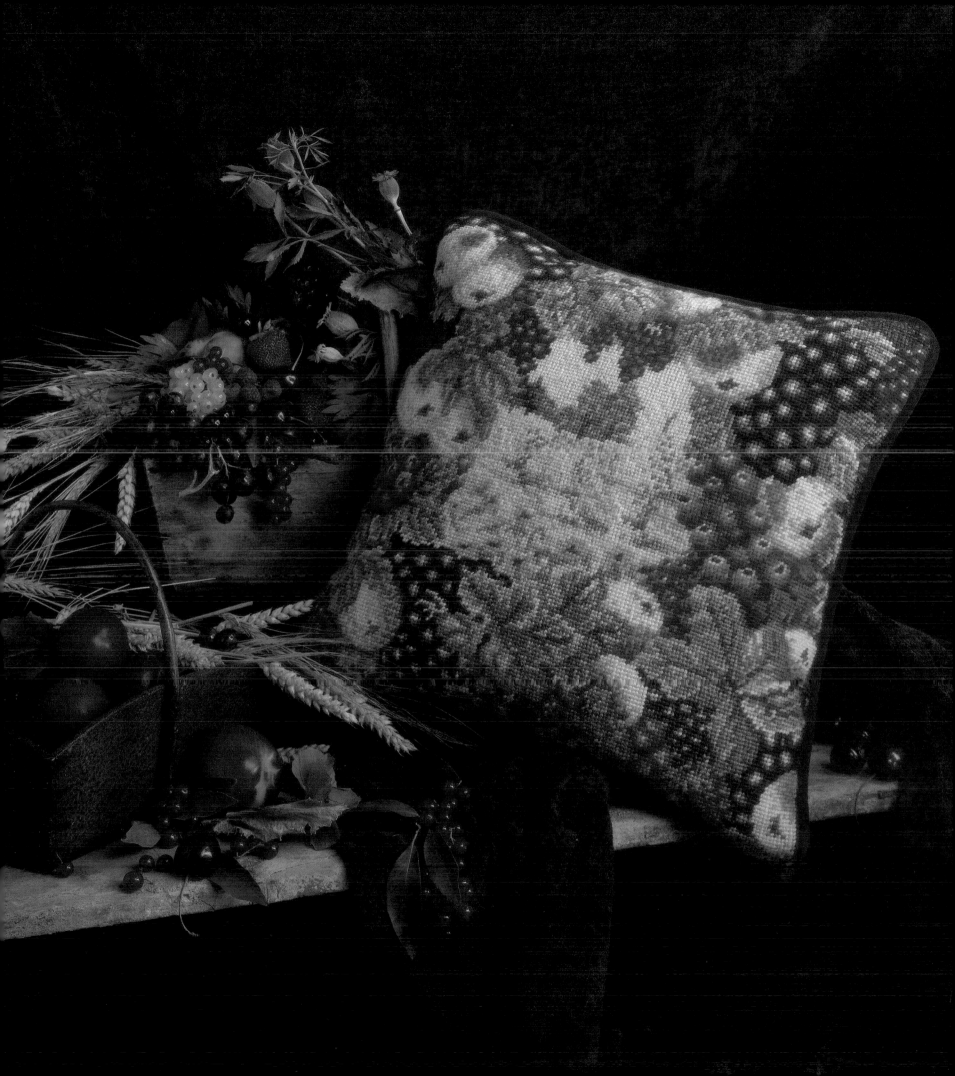

RUSSIAN TAPESTRY
by Jill Gordon

The fruits in the border of the 'Russian Tapestry' are so vivid that you want to pick them up and eat them. The idea was developed from a fragment of an old woven Russian tapestry. Jill decided to surround the soft, pastoral landscape with a rich, lush border of fruits and leaves. The use of colour is sensational and captures perfectly the warm, still light of a summer afternoon. Look particularly at the remarkable shading of the sky.

MATERIALS
Persian wool (see Colourways). The amounts given are for Persian wool (used double) worked in basketweave or continental tent stitch. If the design is worked in half-cross stitch, 30 per cent less wool is required. Double-thread or interlock canvas is suitable for all three types of tent stitch, but if basketweave or continental tent is used an ordinary mono canvas may be substituted. One strand of tapestry wool or four strands of crewel can be substituted for the two strands of Persian wool used for this design. (To calculate amounts for crewel wool see page 113.)
10-mesh double or mono interlock canvas 55cm (21in) square
Size 18 tapestry needle
55cm (21in) furnishing fabric for backing
2m (2¼yd) narrow piping cord
Cushion pad (pillow form) 42cm (16½in) square
30cm (12in) zip fastener (optional)
Scroll or stretcher frame (optional)
Tools and materials for preparing canvas (see page 114) and for blocking (page 115)

The finished cushion measures 42cm (16½in) square and is worked on 10-mesh canvas.

WORKING THE EMBROIDERY
Prepare the canvas and mount it on the embroidery frame, if used (see pages 114 and 115).
Following the chart on the right and using two strands of Persian wool, work the design in basketweave or continental tent stitch, or in half-cross stitch.

BLOCKING AND MAKING UP
Block the completed work (see page 115) and allow it to dry thoroughly. Trim the canvas edges, leaving margins of 2cm (¾in).
From the backing fabric cut a piece 46cm (18in) square. Or, if inserting a zip, cut two pieces as specified on page 116.
From the remaining fabric, cut and join bias strips to cover the piping cord (see page 117). Make up the piping. If using a zip, insert it in the back cover (see page 116). Attach the piping to the back cover as described on page 117.
Join the front and back covers as described on page 117, and insert the cushion pad.

COLOURWAYS AND YARN AMOUNTS
The cushion cover pictured was worked in Paterna Persian wool. DMC tapestry wool colours are given as an alternative; you should note, however, that colours in an alternative brand of yarn will only provide approximate equivalents.

■	12m	(13yd)	of Paterna	571	(or DMC 7823)
■	12m	(13yd)	of Paterna	510	(or DMC 7288)
■	22m	(24yd)	of Paterna	511	(or DMC 7695)
■	3m	(3yd)	of Paterna	503	(or DMC 7802)
■	7m	(7yd)	of Paterna	505	(or DMC 7302)
■	7m	(7yd)	of Paterna	506	(or DMC 7301)
■	12m	(13yd)	of Paterna	522	(or DMC 7598)
■	21m	(22yd)	of Paterna	642	(or DMC 7355)
■	27m	(29yd)	of Paterna	652	(or DMC 7363)
■	26m	(28yd)	of Paterna	653	(or DMC 7361)
■	8m	(8yd)	of Paterna	654	(or DMC 7371)
■	27m	(29yd)	of Paterna	940	(or DMC 7138)
■	17m	(18yd)	of Paterna	951	(or DMC 7544)
■	21m	(22yd)	of Paterna	952	(or DMC 7849)
■	17m	(18yd)	of Paterna	954	(or DMC 7760)
■	24m	(26yd)	of Paterna	846	(or DMC 7853)
■	15m	(16yd)	of Paterna	855	(or DMC 7173)
■	9m	(9yd)	of Paterna	727	(or DMC 7727)

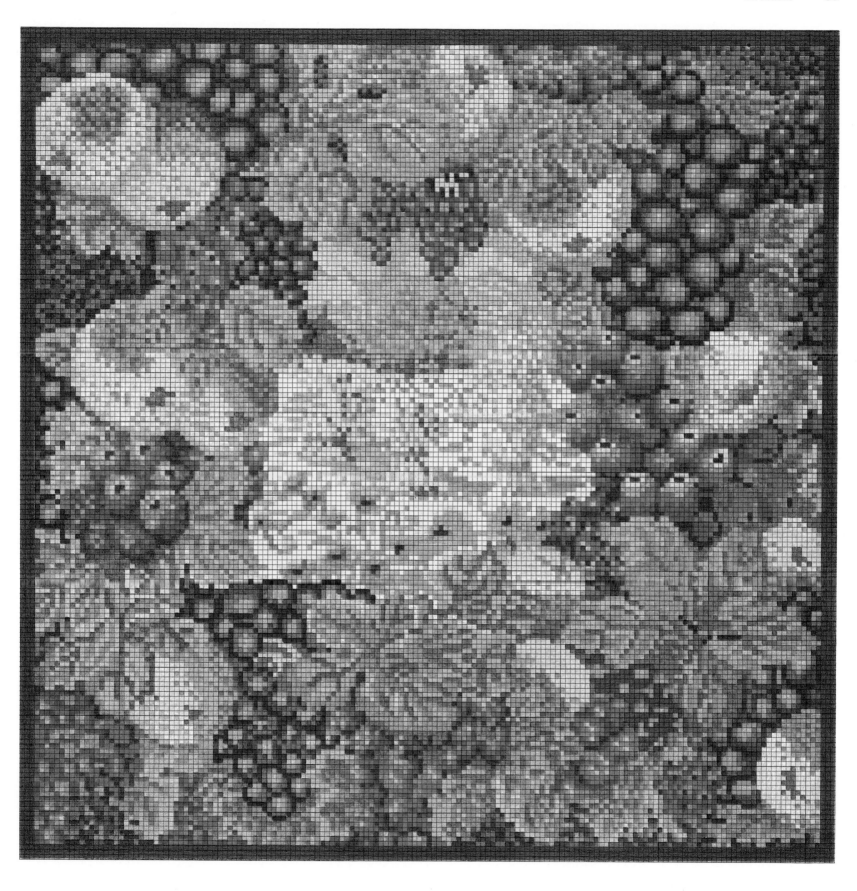

After the detail and complexity of 'Russian Tapestry' we can turn in contrast to the bold outlines and bright colour splashes of Lillian Delevoryas's 'Mexican Cushion' opposite. If Arcadian implies a sense of freedom and joyfulness I think this design encapsulates it. It is a large comfortable cushion 505×505mm (20in square), worked on 7 holes to the inch canvas using tapestry wool stitched double. For a change we have worked this particular design in cross rather than half-cross stitch which, although more expensive because of the greater amount of yarn used, does give it a firmer feel.

It is called 'Mexican Cushion' more for its colours than its style; although the combination of simple floral motifs and geometrics is commonly found in Latin American textiles. It was about ten years ago that designers in Britain became aware of the flamboyant, electric-coloured clothes worn by the Indians of Central America and, in particular, the costumes of Guatemala. Colour magazines were full of pictures of Mexican markets or the religious festivals at Chichicastenango where the men wore brightly coloured three-quarter-length trousers and astonishing Alice-in-Wonderland hats. It opened up a new spectrum to textile designers of all types rather as the fascination with India and the East had done for an earlier generation. Much brighter colours began to appear in all types of interior decoration, particularly furnishing fabrics. And this is the history of Lillian Delevoryas's 'Mexican Cushion' which started life as a fabric design for Designers Guild. It was one of a number of similar sketches that she had been working on but which had not been put into production. I had gone to visit Lillian to discuss projects for tapestries and she suggested that we should go for a rummage in her attic. Rummaging in Lillian's attic was nearly always productive as she hoarded a mass of sketches, paintings and watercolour ideas that poured in torrents from her creative mind. She is one of the most prolific artists I have ever met. Looking through her collection that day we both thought that the Mexican fabric should become the Mexican tapestry and with some adaptations and minor colour changes here it is. It

makes a refreshingly different cushion, quite unlike anything else in the book. It is a large cushion, which it needs to be having such bold pattern. It is easy to work as it is formed of blocks of colour and makes a welcome change from the fine detail found in many of our kits.

Lillian Delevoryas is another designer with whom Ehrman has had a very long association and who, once again, has been connected over the years with Kaffe Fassett. She was a painter working in New York when Kaffe persuaded her to come to England in the late 1960s. For a number of years they worked closely together founding the Weatherall Workshops in Gloucestershire. Lillian was the other principal designer for Designers Guild in their early days and Tricia Guild probably produced more of Lillian's fabric designs than Kaffe's. Lillian then launched an immensely successful range of postcards and greeting cards, wrapping papers and gift tags. They were the first exciting range of their type produced in Britain. It was a common enough idea in America but it took an American to bring it to England. One of the most beautiful and successful ranges currently available is by Steve Lovi, the still-life photographer, another American and friend of Kaffe Fassett.

In the mid-1980s Lillian became disenchanted with designing for mass production and went back to painting full time. She ran a gallery near her house in Gloucestershire for a number of years and then two years ago decided to return to America. I miss her enthusiasm and American energy but, the way our business runs, I am sure our paths will cross again. Some of her best tapestry designs were her earliest when she had the time to stitch large wallhangings and panels, rather as Kaffe does today.

Ehrman regularly introduces the work of new designers as a matter of principle. In this chapter we have 'Bright Daisies' by Alison Hoblyn, which is only her second piece of needlework design. Alison is by training a textile designer but she is also one of our customers. She rang to say that she liked our catalogue and had some suggestions for tapestry design. Alison's

'Mexican Cushion' by Lillian Delevoryas (opposite page). *With bolder, more abstract shapes coming back into style for carpets and furnishing fabrics it is nice to have a design on this scale for a change. Its bright, summery colours would obviously suit a hot climate, but it would also go well in many contemporary, less decorated interiors. There is something immensely cheerful about colours lit with sunlight. 'Light is the first of painters. There is no object so foul that intense light will not make it beautiful.' Ralph Waldo Emerson (1830-1882) from* Nature.

'Bright Daisies' by Alison Hoblyn
(right). *A very simple design,
combined here with unexpected
colours, creates an original
tapestry. Roughly outlined daisy
heads are dotted around an outer
ring on an azure-blue background
while the central pattern is
composed of a repeating series of
daisies laid end-to-end. The
unexpected element is the colour of
the intervening borders where lime
green, fluorescent pink and bright
yellow are mixed to great effect.
They are used sparingly, so, far
from being crude or overpowering,
they add a sparkle to the overall
design that looks perfectly in place.
Often a simple pattern offers the
best opportunity to experiment with
unusual colours like these.*

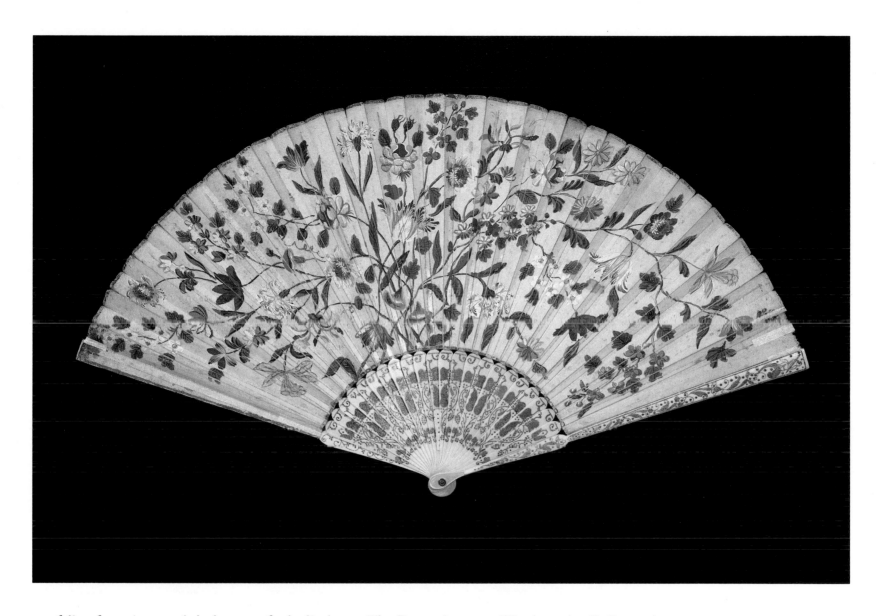

portfolio of previous work had a very fresh, lively feel to it and her confidence that she could bring something different to our tapestry range was a tonic. She had never designed a tapestry before but this didn't worry me as I could see her fondness for bright colour. It is usually the subtle, quieter shades that pose a problem for novices. The result is a very original and attractive cushion and I am delighted that she decided to have a go. The white daisies and splashes of lime green have a twinkling, magical quality on the intense blue and, for that reason alone, it finds itself in this chapter.

The Romantic poets, Wordsworth, Shelley and earlier Blake struck a deep chord in the English psyche reflecting a subjective and mystical counter-balance to the more rational and orderly side of our temperaments. The flowering of landscape art in the early nineteenth century, the British interest in gardening and general awareness of the natural world — the great outdoors — seemed to grow as society became more ordered, urban and mechanical. This contradiction has been with all Western societies ever since. It is as though we wish to assert the power of nature the more we tame it. This doesn't seem odd to me at all.

This fan (above) *is in the collection of the Victoria and Albert Museum, London. Elizabeth I created the vogue for carrying a fan and early Stuart fans had hand-pierced vellum mounts to create a lace effect. During the Restoration period they often featured classical scenes to match the classical costumes adapted to the mood of the day.*

The less you have of something, the more you value it. The less you know it, the more you romanticise it. Our obsession with open countryside, fresh air, trees and natural products is because we need them, and we only know we need them when we don't have them. You only have to see the traffic jams caused by families escaping cities on a Friday evening to appreciate the scale of the need. In Japan you can even buy bottled fresh air! A sentimental longing for a long-lost rustic idyll (which never really existed), lurks at the back of many a modern subconscious and Ann Blockley's 'Cottage Garden' looks at first to be a parody of this idealised vision. In fact, it harks back to a previous era of romantic design, the 1930s, and is intended as an affectionate tribute to that particular genre of needlework.

When I think of British images from the 1930s I don't think of modernism or the fashions of the time. It was the age of the suburb and the countryside, not the metropolis, of John Betjeman, boats and beaches, Miss Marple, the country cottage and its pretty, overdone garden. Ann Blockley takes this very British tradition but filters it through her own colour lens. The clear, hard-edged colours of the originals are replaced with the soft, pastel, candlelight tones of her design and she has added the delightful wide floral border. It is a triumphant exercise in delicate and subtle colour gradation. When we first saw the model stitched up, we wondered if the centre was too hazy to be decipherable, but I felt this was its charm. Photographed as a cushion opposite, it goes almost without saying that it would work equally well as a picture.

This eighteenth-century porcelain flowerpiece (right) *from the Wallace Collection in London, which forms part of a writing table, was made at the Sèvres factory in France. The French national porcelain factory led European ceramic fashion from 1760 to 1815. Its chief client and chief salesman was the King. From 1758 an annual sale of Sèvres products was held in the King's private dining-room at Versailles and courtiers were expected to buy. Plaques, like the one seen here decorated with sprays of flowers, were painted in the style of Boucher and used, from 1760 onwards, to adorn all sorts of furniture.*

'Cottage Garden' by Ann Blockley (left).

'God Almighty first planted a Garden. And indeed, it is the purest of human pleasures . . .' Francis Bacon (1561-1626). When you say country cottage what does it conjure up? In Britain a wide variety of styles: the trim brickwork of East Anglia, the colour-washed lump and thatch of Devon, the crisp weatherboarding of Kent, the soft stone of the Cotswolds, the hard lime and sandstone of the Pennines or the heavy timbering of the West Midlands. They are all built on a small scale (usually two storeys at the most) by local craftsmen out of local materials and this almost gives the impression that they grew out of the landscape. The scale of these buildings is echoed in their gardens, and the cottage garden of popular imagination is full of all sorts and varieties of flowers, packed in to make up for the lack of space. These gardens, with their wealth of colour, are as familiar a part of the English village as the church spire, the pub, the green and the old rectory. Or at least they were until recently; now this is a traditional picture of rural life increasingly under threat. Ann Blockley's 'Cottage Garden' has a pre-war feel to it when this gentle style of overgrown abundance had its heyday.

COTTAGE GARDEN
by Ann Blockley

Ann Blockley's 'Cottage Garden' harks back to a previous era of romantic design, the 1930s, and is intended as an affectionate tribute to that genre of needlework. The clear, hard-edged colours of the originals are replaced with the soft, pastel candlelight tones of her design and she has added the delightful wide floral border. It is a triumphant exercise in delicate and subtle colour gradation.

MATERIALS
Tapestry wool (see Colourways). The amounts given are for tapestry wool worked in basketweave or continental tent stitch. If the design is worked in half-cross stitch, 30 per cent less wool is required. Double-thread or interlock canvas is suitable for all three types of tent stitch, but if basketweave or continental tent is used an ordinary mono canvas may be substituted. Three strands of Persian wool or four strands of crewel can be substituted for the single strand of tapestry wool used for this design. (To calculate amounts for crewel or Persian wool see page 113.)
10-mesh double or mono interlock canvas 50cm (19in) square
Size 18 tapestry needle
50cm (19in) furnishing fabric for backing
1.8m (2yd) narrow piping cord
Cushion pad (pillow form) 38cm (15in) square
30cm (12in) zip fastener (optional)
Scroll or stretcher frame (optional)
Tools and materials for preparing canvas (see page 114) and for blocking (page 115)

The finished cushion measures 38cm (15in) square and is worked on 10-mesh canvas.

WORKING THE EMBROIDERY
Prepare the canvas and mount it on the embroidery frame, if used (see pages 114 and 115).

Following the chart on the right and using a single strand of tapestry wool, work the design in basketweave or continental tent stitch, or in half-cross stitch.

BLOCKING AND MAKING UP
Block the completed work (see page 115) and allow it to dry thoroughly. Trim the canvas edges, leaving margins of 2cm (¾in).

From the backing fabric cut a piece 42cm (16½in) square. Or, if inserting a zip, cut two pieces as specified on page 116.

From the remaining fabric, cut and join bias strips to cover the piping cord (see page 117). Make up the piping.

If using a zip, insert it in the back cover (see page 116).

Attach the piping to the back cover as described on page 117.

Join the front and back covers as described on page 117, and insert the cushion pad.

COLOURWAYS AND YARN AMOUNTS
The cushion cover pictured was worked in Anchor tapestry wool. DMC tapestry wool colours are given as an alternative; you should note, however, that colours in an alternative brand of yarn will only provide approximate equivalents.

■	8m	(9yd)	of Anchor	0848	(or DMC 7293)
■	21m	(23yd)	of Anchor	3094	(or DMC 7594)
▨	21m	(23yd)	of Anchor	0144	(or DMC 7715)
▨	28m	(31yd)	of Anchor	0981	(or DMC 7280)
■	19m	(21yd)	of Anchor	024	(or DMC 7760)
■	22m	(24yd)	of Anchor	0608	(or DMC 7853)
▨	61m	(67yd)	of Anchor	0740	(or DMC 7191)
■	28m	(31yd)	of Anchor	0505	(or DMC 7333)
▨	16m	(18yd)	of Anchor	0504	(or DMC 7321)
▨	16m	(18yd)	of Anchor	3087	(or DMC 7424)
▨	9m	(10yd)	of Anchor	0388	(or DMC 7523)
■	8m	(9yd)	of Anchor	0377	(or DMC 7465)
▨	31m	(34yd)	of Anchor	0498	(or DMC 7950)
▨	14m	(16yd)	of Anchor	0426	(or DMC 7173)
▨	19m	(21yd)	of Anchor	3370	(or DMC 7905)
□	50m	(55yd)	of Anchor	0402	(or DMC white)

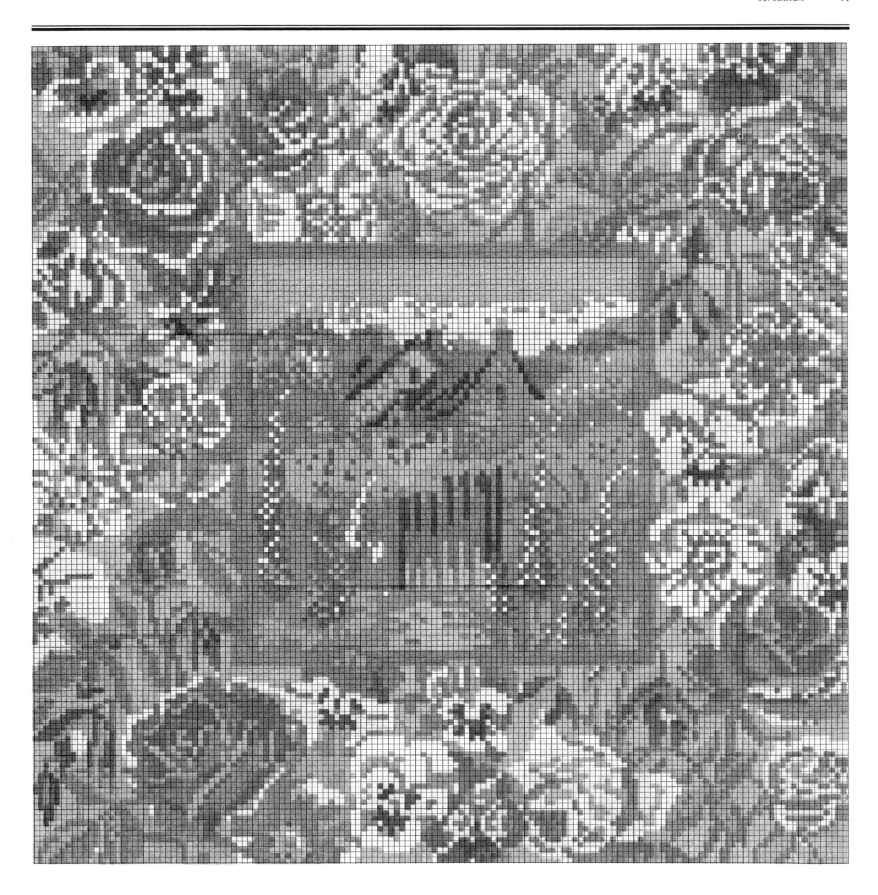

A section of border (above) *taken from an English Mortlake tapestry from the 1670s or 80s entitled* Months of November and December *at the Victoria and Albert Museum, London.*

'Valentine Heart' by Margaret Murton (opposite page).
'Drink to me only with thine eyes,
And I will pledge with mine;
Or leave a kiss but in a cup,
And I'll not look for wine.'
Benjamin Jonson (1573-1637).

With a final romantic flourish we end this chapter, most appropriately, with Margaret Murton's 'Valentine Heart'. For many years Margaret has been drawn to all things Elizabethan – the poetry, clothes and language of the age. Often her tapestry designs have Elizabethan titles or snatches of poetry which act as description. Although this design is clearly twentieth century, its romantic content and, to a certain extent, its colouring are inspired by this interest. Once again this was a new departure for us. At first the idea of a heart-shaped Valentine tapestry sounded cloying but when I saw the watercolour sketches for the design I was convinced. The great truth about design of any type is that no subject is ever right or wrong, just as no colour is ever right or wrong. It all depends on how it is used. We are often asked what our most commercial tapestries are by subject matter. It is a great relief to be able to report that we have no idea. A design of anything will sell entirely on the intrinsic merits of that particular design. It is, however, true that interest in particular subjects seem to go in phases. Originally nearly all our kits were floral. There followed a craze for cats (but never dogs), and after the publication of Kaffe Fassett's book, *Glorious Needlepoint*, fruits and vegetables were in demand. That was an interesting addition of subject material to the field of tapestry. It is curious to think that before Kaffe Fassett produced his fruits and his cabbage and cauliflower, there were no designs of vegetables and only a few of fruits available to stitch.

Choosing subjects for needlework design is endless but originality for its own sake is unnecessary. It would be impossible to exhaust the subject matter of the natural world. You could stitch tapestries of roses, for example, without ever running out of ideas or inspiration. Looking again at Thomasina Beck's excellent book *The Embroiderers' Garden* a quotation she uses caught my eye. It is from a lecture William Morris gave in 1899 on pattern designing:

> However original a man may be, he cannot afford to disregard the works of art that have been produced in times past when design was flourishing; he's bound to study the old examples and get what is good out of them without making a design which lays itself open to plagiarism.

All the designers Ehrman works with use museums and books as source material not in a plagiaristic way but as a repository of knowledge. A brief look at the textile collection of any museum which is lucky enough to have one will surprise you. Objects and items which you would never have expected appear as motifs. Kaffe Fassett's cabbages and cauliflowers may have astonished people when they appeared as kits but they shouldn't have done. These same vegetables regularly appeared in eighteenth-century French woven tapestries. Needleworkers of the past were exceedingly imaginative and wide-ranging with their choice of subject matter so a study of older textiles will yield a rich reward for those seeking inspiration.

A study of the past, as William Morris implies, will also reveal a consistency of pattern over the centuries. Certain patterns and design structures recur in textiles from any period: borders, floral motifs, stripes will always be used by any age. The repeating pattern, usually floral, is the most common of all and in the next chapter we look at some contemporary examples.

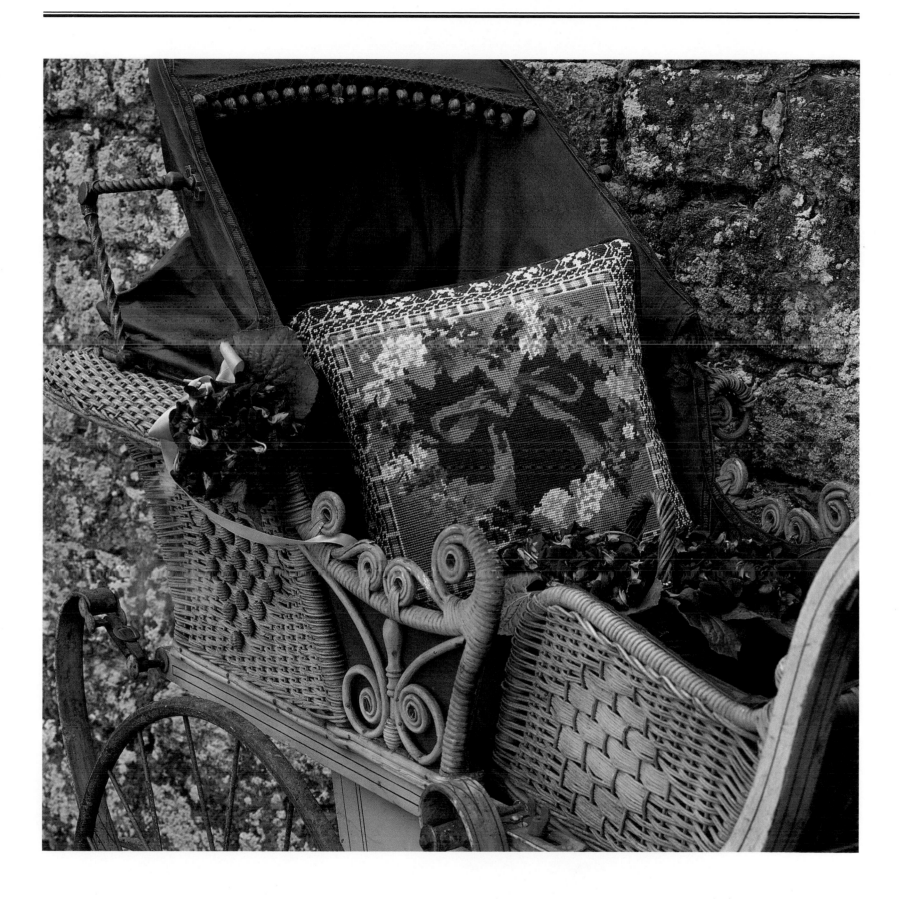

PATTERN
REPEATS

A section (opposite page) *from a mid-seventeenth-century embroidered English bed valance at the Victoria and Albert Museum, London, is an extraordinary example of a pattern which appears to repeat but is actually irregular in almost every aspect. Motifs are repeated, but at differing intervals, whilst their sequence also changes. But the scale of the animals contrasted with that of the fruits creates a crisscross pattern and it looks, at first glance, like any other pattern repeat.*

This combination of flowers and fruits with animals was typical of the period. Elizabeth Benn has pointed out that the design sources for these embroideries can be traced to the woodblock prints and engravings in the illustrated bibles, herbals and bestiaries that proliferated during the sixteenth and seventeenth centuries. A Book of Beasts, Birds, Flowers, Fruictes, Flies and Wormes *published by Thomas Johnson in London, 1630, was particularly popular. It was also around this time that the skilled execution of minute stitches reached its zenith.*

The design of this valance is a combination of skill and charm. The worms, butterflies, snails and caterpillars are stitched with a painstaking attention to detail while the waving angles of fruits, flowers and leaves give motion to the overall composition.

Pattern is the natural result of repetition, so the term 'pattern repeats' is something of a tautology. It does, however, have a specific descriptive meaning which we all understand fairly well. Lewis Day, in his book published in 1903 on pattern design, wrote:

> Take any form you please and repeat it at regular intervals, and, as surely as recurrent sounds give rhythm or cadence, whether you want it or not, you have pattern. It is so in nature, even in the case of forms either identical nor yet recurring at set intervals. The daisies make a pattern on the lawn, the pebbles on the path, the dead leaves in the lane.

Wherever you look in nature, pattern stares back at you, so it is hardly surprising that so many pattern repeats employ this ready-made source material. However, as Lewis Day went on to say, 'Technically speaking, however, we understand by pattern not merely the recurrence of similar forms, but their recurrence at regular intervals.' The skill of the designer is to select a shape or form which when repeated becomes a pattern of beauty and which works in the appropriate scale for its context. This is very different from simply painting a picture and repeating it. Some of the designs in this chapter will only repeat once, like a mirror image – the 'Grapes' and 'Rhododendron Rug' on pages 59 and 60 fall into this category – while designs such as the 'Strawberry Chairseat' or 'Lattice and Poppies' on pages 57 and 49 duplicate simple motifs over and over. All are repeat patterns in their different ways and they illustrate the latitude of scale you can employ. Experimenting with repeat patterns is one of the easiest and most satisfying ways of starting to design. All that is required is a sense of appropriate scale and a certain geometric discipline.

The most elementary forms of pattern repeat are usually found in borders: chevrons, zigzags, waves, interlacing and plaited ropes, ribbons, scrolls and crests are all patterns which appear repeatedly in the borders of our kits. They are very useful for holding together loosely structured designs. A wide border repeated inwards, adapted and modified can often produce a lovely geometric design in itself, and it is not unheard of for designers to take the border as the starting point for their tapestry. I have not included all the many examples of pattern repeat borders in this chapter but have tried to concentrate instead on the designs which use all-over pattern. They all have a fairly classical and restrained feel to them. They do not overpower, they are easy to live with and should give some ideas, I hope, to those of you who like to design your own tapestries. One great advantage about pattern repeats is that they can be infinitely adapted. The 'Strawberry Trellis' design, pictured here on a chair, would be just as good for cushions or stool tops as would the 'Lattice and Poppies'. Adapting designs with fewer repeats needs a little more caution but I could imagine the grapes cushion worked up in squares to make a wonderful rug or the fuchsias spectacle case extended and repeated laterally to form a striped cushion. Pattern repeats are source material for your own projects and if you use the simpler ones it is easier to experiment with your own colours.

Embroidery of all sorts is free of the necessity to repeat a pattern. Pattern repeats are more normally associated with printed fabrics and textiles, wallpapers or silks where the method of their production limits the scope of their design. A craft which is executed entirely by hand knows no such limitations. This is a tremendous artistic advantage. By using pattern repeats the stitcher can add touches of irregularity which can give the design a new dimension. Kaffe Fassett often employs this twist. If you look at his 'Christmas Fruit' on page 21 you'll see what appears to be a formal repeat border of leaves, ribbons and fruits. But look closer and you'll see that no section exactly echoes any other. Each is very slightly different and this variation gives it an added life. Try taking any perfect repeat and adding a few unexpected changes of colour or motif at random and the result can be very exciting. It is what makes oriental textiles so interesting. If you look in detail at any Persian carpet that appears to repeat regularly you will find on closer inspection that it doesn't. A human touch of disharmony jumps in unexpectedly. A splash of green in a blue pattern, a missing leaf, or a temporarily

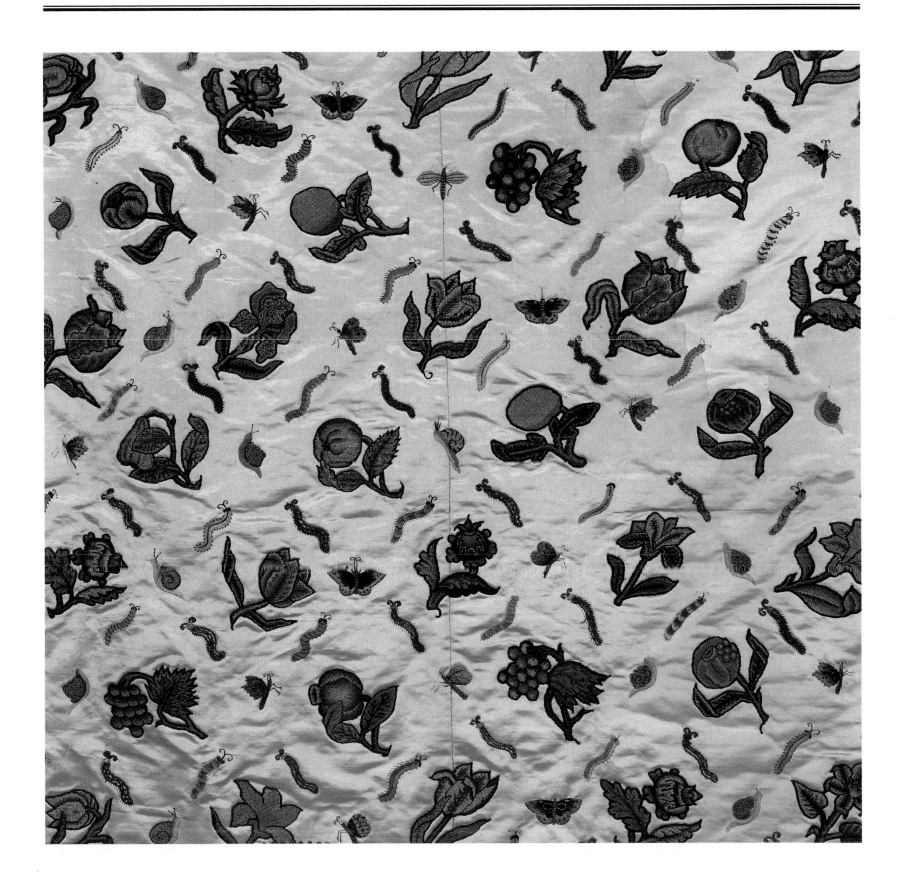

'Lattice and Poppies' by Deborah Kemball (opposite page).

Wrapped Oranges (below) *by William J. McCloskey (1859-1941), the Amon Carter Museum. The rich, deep colouring of these oranges with their soft grades of shading remind me of Kaffe Fassett's needlework fruits. Kaffe manages to capture in wool the shiny lustrous surfaces common to most fruits which have fascinated painters over the ages.*

wavy stripe testify to the individuality of the weaver on that particular section and proclaims that this is made by hand not machine.

Pattern repeats also make very good backgrounds. Plaids and tartans are often used as backdrops for floral motifs. Susan Duckworth, one of the leading British knitwear designers, often scatters individual flowers over tartan backgrounds and Kaffe Fassett is currently working on a chairseat in blue plaid with leaves and fruit overlaid. But in this book we are dealing with floral not geometric pattern repeats and one of the most graphic and simple examples is Deborah Kemball's 'Lattice and Poppies' opposite. Its

simplicity is its success. There is no unnecessary clutter to obscure her beautifully detailed poppies, all of which face in different directions. And here is the surprise; it is not as simple as it looks after all. By never copying exactly the shape of a poppy a simple repeat pattern becomes something far more exciting, adding a sense of fresh movement to what might have become a static design. A wind is blowing through this poppy field but the geometric structure is held firmly in place by the interlocking grid of ribbon and leaves. It is a skilfully constructed piece of needlework and its soft, well-chosen colours have a timeless air to them.

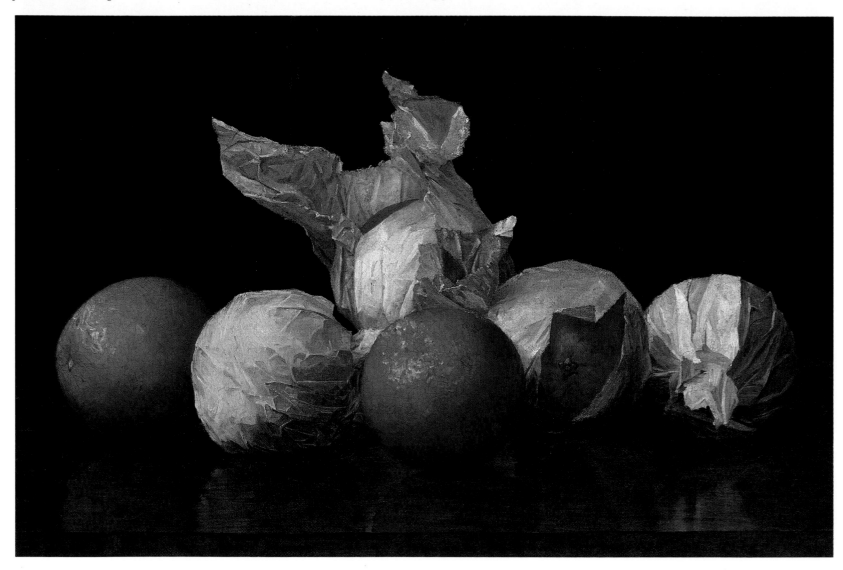

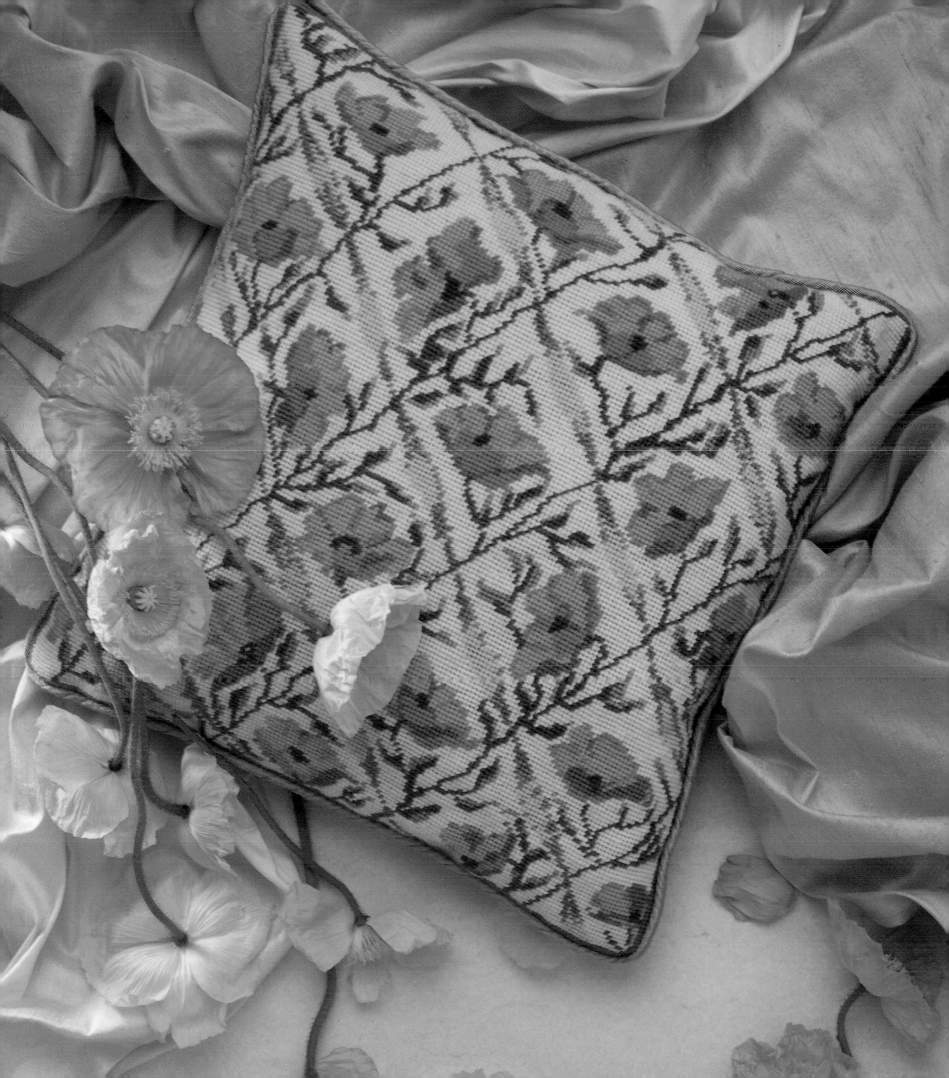

LATTICE AND POPPIES
by Deborah Kemball

The simplicity of Deborah Kemball's 'Lattice and Poppies' is its success. There is no unnecessary clutter to obscure her beautifully detailed poppies, all of which face in different directions. And here is the surprise; it is not as simple as it looks after all. By never copying exactly the shape of a poppy a simple repeat pattern becomes something far more exciting, adding a sense of fresh movement to what might have become a static design.

MATERIALS
Tapestry wool (see Colourways). The amounts given are for tapestry wool worked in basketweave or continental tent stitch. If the design is worked in half-cross stitch, 30 per cent less wool is required. Double-thread or interlock canvas is suitable for all three types of tent stitch, but if basketweave or continental tent is used an ordinary mono canvas may be substituted. Two strands of Persian wool or three strands of crewel can be substituted for the single strand of tapestry wool used for this design. (To calculate amounts for crewel or Persian wool see page 113.)
12-mesh double or mono interlock canvas 45cm (18in) square
Size 18 tapestry needle
45cm (18in) furnishing fabric for backing
1.6m (1¾yd) narrow piping cord
Cushion pad (pillow form) 36cm (14in) square
25cm (10in) zip fastener (optional)
Scroll or stretcher frame (optional)
Tools and materials for preparing canvas (see page 114) and for blocking (page 115)

The finished cushion measures 36cm (14in) square and is worked on 12-mesh canvas.

WORKING THE EMBROIDERY
Prepare the canvas and mount it on the embroidery frame, if used (see pages 114 and 115).

Following the chart on the right and using a single strand of tapestry wool, work the design in basketweave or continental tent stitch, or in half-cross stitch.

BLOCKING AND MAKING UP
Block the completed work (see page 115) and allow it to dry thoroughly. Trim the canvas edges, leaving margins of 2cm (¾in).

From the backing fabric cut a piece 40cm (15½in) square. Or, if inserting a zip, cut two pieces as specified on page 116.

From the remaining fabric, cut and join bias strips to cover the piping cord (see page 117). Make up the piping.

If using a zip, insert it in the back cover (see page 116).

Attach the piping to the back cover as described on page 117.

Join the front and back covers as described on page 117, and insert the cushion pad.

COLOURWAYS AND YARN AMOUNTS
The cushion cover pictured was worked in Appleton tapestry wool. DMC tapestry wool colours are given as an alternative; you should note, however, that colours in an alternative brand of yarn will only provide approximate equivalents.

- ■ 5m (5yd) of Appleton 866 (or DMC 7920)
- ■ 17m (18yd) of Appleton 863 (or DMC 7176)
- ■ 21m (22yd) of Appleton 862 (or DMC 7175)
- ■ 29m (31yd) of Appleton 861 (or DMC 7173)
- ■ 30m (32yd) of Appleton 644 (or DMC 7702)
- ■ 14m (15yd) of Appleton 641 (or DMC 7333)
- ■ 27m (29yd) of Appleton 154 (or DMC 7285)
- ■ 8m (8yd) of Appleton 152 (or DMC 7292)
- ■ 11m (12yd) of Appleton 876 (or DMC 7928)
- □ 100m (109yd) of Appleton 992 (or DMC écru)

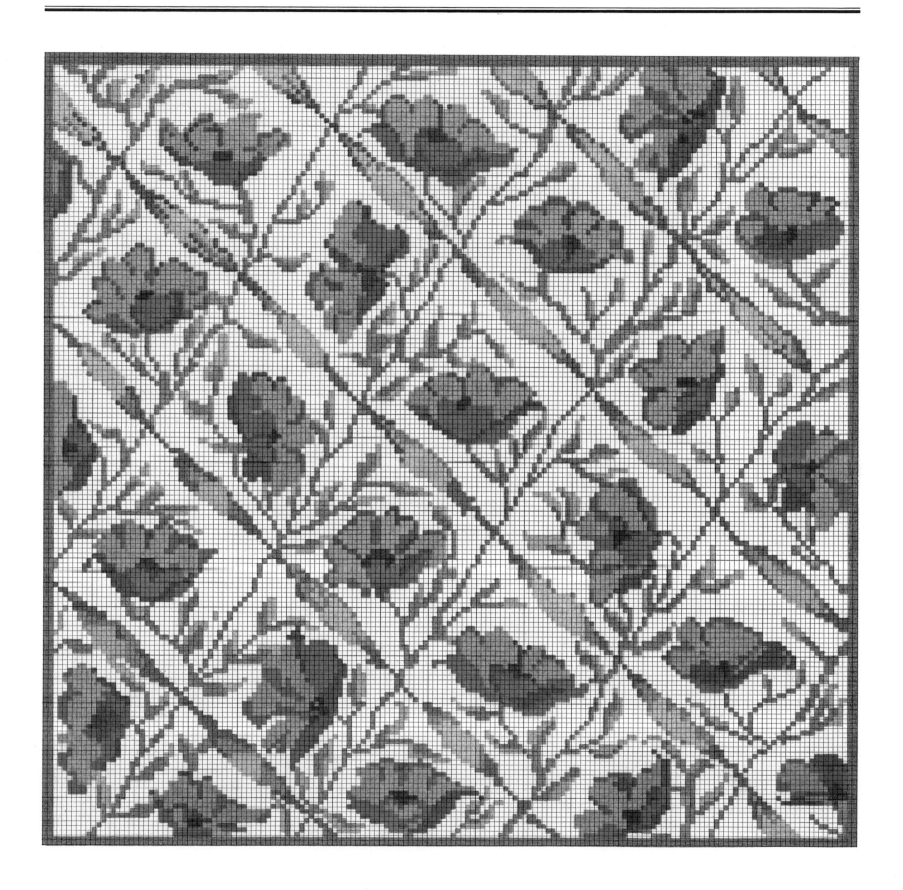

'Fuchsia Spectacles Case' by Nancy Kimmins (right). *A small project for a change which might be a good design for a beginner to start on.*

Nancy Kimmins, who designed the fuchsias spectacle case, was introduced to me by the Embroiderers' Guild. I am very honoured to be a co-opted member of the Executive Committee of the Guild, as it is a splendid institution with branches all over the countryside. It has done more to maintain and revive interest in needlework in Britain than any other body. Members are involved in a host of activities at all levels, there is a fine collection of embroidered textiles at their Hampton Court headquarters and they take an active interest in contemporary design of all types. This blend of intelligent scholarship with a missionary enthusiasm is most invigorating and if you are not already a member, rush to your local branch and sign on now! Elizabeth Benn, who has just recently retired as chairman, was the guiding force for many years, and she wrote the outstanding text for our last book *Noah's Ark*. I have known Elizabeth over a number of years – in fact she was the very first customer to our craft shop in 1978 when she was editor of the *Daily Telegraph* Woman's Page. So the connection goes

back a long way and she was always one of the most enthusiastic and supportive allies in helping to establish our kit business when we started. Nancy Kimmins had done a series of design projects for the Guild and the Guild put me in touch with her. Nancy has taught needlework design for many years and that experience can be seen in the careful structuring of such a limited number of stitches. She has captured a sense of movement with bold scale in a very small area, not an easy thing to do, and her fresh pinks and purples sing out on the bottle-green background.

This chapter is different from the others in the book in one important aspect. It is the only chapter where the craft of geometry and precision takes precedence over pictorial depiction. A repeat pattern doesn't work if it doesn't repeat. That is fairly obvious. So the designers whose work features in this chapter must have the basic skills of a draughtsman. Nearly all designers have this naturally, like a sense of perspective, but on these tapestries it comes to the fore. In one of his television series Kaffe Fassett spoke

of building patterns by experimenting with collections of small objects – marbles, postcards, buttons or anything – and seeing how they fell into groups and shapes. Then start to play with them, as a child might, but stop when something interesting emerges. Byzantine mosaic workers were content to play with variations upon familiar combinations of triangles and cubes, and Islamic patterns are complex variations of geometric shapes similar to those you might see through a kaleidoscope. Floral patterns are a little different as they usually involve a fluid waving motion or intertwining, and that is why criss-cross patterns and grids have been so popular over the ages. They act as a firm structure on which to embellish, and the diamond patterns they create can be filled with single motifs. Kathleen McKenzie filled the spaces on her chairseat pattern with strawberries (pages 56-7).

Sky-blue, yellow and strawberry pinks are an intoxicating combination with a distinctive American feel. Kathleen originally intended to give this design a more formal cream background but changed to the blue at the last minute. In fact, it is a design which would work well on a number of coloured backgrounds and you might like to experiment with this yourself.

A needlework pattern repeat is often the nearest in look to an upholstery fabric and goes well with furniture. It can also be cut into to fit a particular chair without looking too odd. You can cover the back and arms in tapestry as well. It would be pointless for Ehrman to produce individual kits for these different sections as all chairs are different shapes and sizes. If you have a chair similar to the one in the photograph and wish to cover the sides and arms, this is how to do it. Buy two kits and adapt them as follows. Use the first kit to make the chairseat then take the second canvas and work out the area required for stitching the back and arms with a felt tip pen. Stitch a little beyond your outline to give a margin of error and then simply cut the outline of your finished work for the final upholstery. One kit, measuring 505×505mm (20in square), which is the standard chairseat-sized canvas, would be large enough for the back and arms of this chair. Bolder or more figurative patterns are harder to adapt in this way but, with a little imagination and planning, these fairly small repeat patterns are ideal.

This design is traditional in conception but given an unexpected turn with the choice of colours. This is very much Kathleen McKenzie's style. She has worked on individual commissions for a number of years and the clients she attracts tend to be looking for more formal designs to go with their antique furniture. She is very good at interpreting these requirements but, in addition, has an excellent sense of colour and style of her own which separates her work completely from the 'Repro' market. This combination of originality and appreciation of classical design can also be seen in her simple basket of flowers in the next chapter. She brings a fresh touch of colour and composition to familiar themes.

To quote again from Lewis Day, 'We are for our part too self-conscious, too anxious about the novelty of what we do. The dishing up of stale patterns is not of course design. But neither does originality mean novelty. An artist of initiative will show marked originality in the treatment of the oldest themes.' There is a strong element of truth in this. As with pattern designs, so with subject matter – a frantic quest for novelty is not necessary. The best tapestries in this section are, on the whole, quiet reworkings of older themes. Adding, recolouring, reinterpreting can last a lifetime. Sicilian silk weavers designed upon the lines of the stripe; Gothic textiles took the continual form of what is called the pine or cone pattern. We don't find this boring. Potters are more relaxed about this – they will rework a familiar shape in a hundred subtly different ways – and similar playing on variations of pattern repeats can give a textile artist this same sense of quiet development. A very calm and soothing design, and one of my personal favourites, is Judy French's 'Grapes' on page 59. The soft, dusty colours give a serenity to this simply executed, almost naïve cushion. I don't think anyone would tire of it quickly and it would work its way comfortably into the fabric of most rooms.

A small section (below) *from an eighteenth-century British printed chintz. These rich floral confections, however complicated, were always repeat patterns so that they could be printed in lengths.*

FUCHSIA SPECTACLES CASE
by Nancy Kimmins

Embroidery of all sorts is free of the necessity to repeat a pattern. Pattern repeats are more normally associated with printed fabrics and textiles, wallpapers or silks where the method of their production limits the scope of their design. A craft which is executed entirely by hand knows no such limitations. This is a tremendous artistic advantage. Working a repeat pattern the stitcher can add touches of irregularity which can give the design a new dimension.

MATERIALS
Tapestry wool (see Colourways). The amounts given are for tapestry wool worked in basketweave or continental tent stitch. If the design is worked in half-cross stitch, 30 per cent less wool is required. Double-thread or interlock canvas is suitable for all three types of tent stitch, but if basketweave or continental tent is used an ordinary mono canvas may be substituted. Two strands of Persian wool or three strands of crewel can be substituted for the single strand of tapestry wool used for this design. (To calculate amounts for crewel or Persian wool see page 113.)
14-mesh mono interlock canvas 20cm by 45cm (8in by 18in)
Size 20 tapestry needle
30cm (12in) fabric for lining
Scroll or stretcher frame (optional)
Tools and materials for preparing canvas (see page 114) and for blocking (page 115)

The finished needlepoint measures 9.5cm by 36cm (3³⁄₄in by 14¹⁄₄in) worked on 14-mesh canvas. The finished case measures 9.5cm by 18cm (3³⁄₄in by 7¹⁄₈in).

WORKING THE EMBROIDERY
Prepare the canvas and mount it on the frame, if used (see pages 114 and 115). The chart on the far right is worked directly below the one on the near right.

Following the charts and using a single strand of tapestry wool, work the design in basketweave or continental tent stitch, or in half-cross stitch.

BLOCKING AND MAKING UP
Block the completed work (see page 115) and allow it to dry thoroughly. Trim the canvas edges, leaving margins of 2cm (³⁄₄in).

Fold the canvas edge back all around and baste in place.

Cut the lining the same size as the needlepoint, plus a 2cm (³⁄₄in) seam allowance all around the edge. Fold the lining in half widthwise, wrong sides together. Join the side seams.

Fold the needlepoint in half widthwise, wrong sides together. Join the side seams of the case. Insert the lining and fold under the top edges. Stitch the lining to the case around the opening.

COLOURWAYS AND YARN AMOUNTS
The cushion cover pictured was worked in Appleton tapestry wool. DMC tapestry wool colours are given as an alternative; you should note, however, that colours in an alternative brand of yarn will only provide approximate equivalents.

- ■ 7m (7yd) of Appleton 804 (or DMC 7157)
- ■ 12m (13yd) of Appleton 801 (or DMC 7255)
- ■ 18m (19yd) of Appleton 101 (or DMC 7241)
- ■ 17m (18yd) of Appleton 884 (or DMC 7260)
- ■ 3m (3yd) of Appleton 501a (or DMC 7106)
- ■ 5m (5yd) of Appleton 209 (or DMC 7448)
- ■ 26m (28yd) of Appleton 646 (or DMC 7701)
- ■ 5m (5yd) of Appleton 545 (or DMC 7988)
- ■ 8m (8yd) of Appleton 252 (or DMC 7583)

 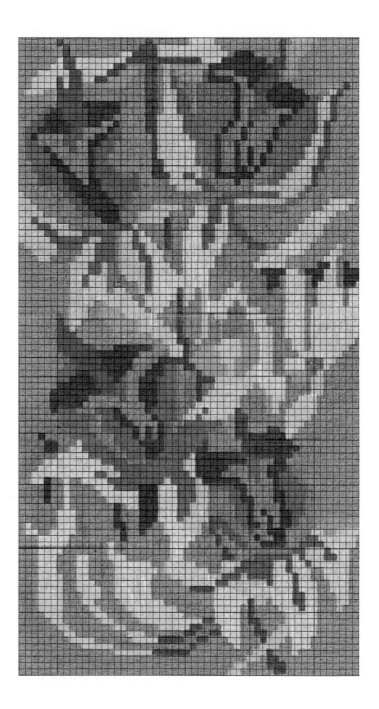

Throughout the 1980s the emphasis of interior decoration was on co-ordination. Wallpapers, curtain and upholstery fabrics were presented together in collections. This trend is dying out and rooms are looking less rigidly uniform and more individual again. A well-decorated room will always depend on a good eye for colours and shapes that work together but what brings it to life are the miscellaneous bits and pieces that reflect the personality of the owner. Tapestries have that individual, personal touch and this is one of the reasons for their current popularity. Another reason is that patterns such as those featured in this chapter are specifically designed for decorating rooms. The pictorial designs seen in the next chapter are not and if they happen to look good in a particular setting it is by accident not design. They are pure and simple exercises in needlework design and are worked for their own intrinsic appeal. Repeat patterns, however, are different as they usually take their inspiration from printed furnishing fabrics and so naturally blend in with them. We have often taken a traditional chintz or an eighteenth-century damask and based a tapestry design on it. As often as not it is a repeat pattern. The textural surface of a stitched tapestry also adds a discoordinated look to a room, even if patterns blend together; so they suit the times. Luckily, fashions in interior decoration change almost imperceptibly and the English have a sensible habit of ignoring them almost altogether. Our very first tapestry kit, 'Caucasian Flower', is still one of our best-sellers after twelve years. Changes in interior style are taken more seriously in America, Germany or Japan but in countries such as England or France, where a larger proportion of the population live in houses built before the Second World War, decoration has to suit the style of the building. Tapestries are not suddenly fashionable one year and not the next, thank goodness.

An over-reverent respect for the past can however become stultifying. Ralph Lauren and Laura Ashley with their constant reworkings of the past have, over the years, produced some wonderful designs. But unless it is handled with consummate skill an air of repetition can creep into this formula. Ehrman has produced many successful designs based on the tapestries of the Arts and Crafts period. It was a highly creative era for needlework design. But we have always sought to adapt or reinterpret these ideas, not simply to copy them. 'The dishing up of stale patterns is not of course design.' Another example of this approach can be found on page 89, with Candace Bahouth's 'Bruges' tapestry. It is based directly on the medieval woven tapestries found in the Cluny Museum in Paris but is a very modern and personal reworking of that style. All the pattern repeats in this chapter are similarly inspired by classical designs but they are not simply copies and, as a result, a fresh range of material has been made available to stitchers. Elizabeth Bradley's designs, which I admire greatly, are a good example of this. They are creative reinterpretations of Victorian themes, not copies.

We finish this chapter with Margaret Murton's 'Rhododendron Rug' on page 60. This shows quite a dramatic change of colour from her group of tapestries in the first chapter. She used similar colours in her 'Valentine Heart' in chapter 2 and this combination of sharp pinks and purples looks excellent on the flat greens she has chosen for the background to this design. You will see that this is not a repeated mirror image but a clever variation on that idea. Reflecting the pattern on itself irregularly gives a single all-over design. It shows how you can juggle the sections of a pattern to create a harmonious but mismatched mirror image and this is often found in pattern repeats. The most commonly found examples are decorative stripes where the patterns repeat at half drops but form a recurring theme. It is the same process as the shifting geometric shapes that I mentioned earlier in connection with Islamic art. The variations of a non-perfect repeat are infinite but the harmony of the whole has to be maintained.

This rug is hand-stencilled on 7-mesh canvas and worked with tapestry wool stitched double. Our rugs of this size need to be printed by hand, as the canvas size is too large for machine-printing. Creating the stencils is a fascinating process. The original artwork

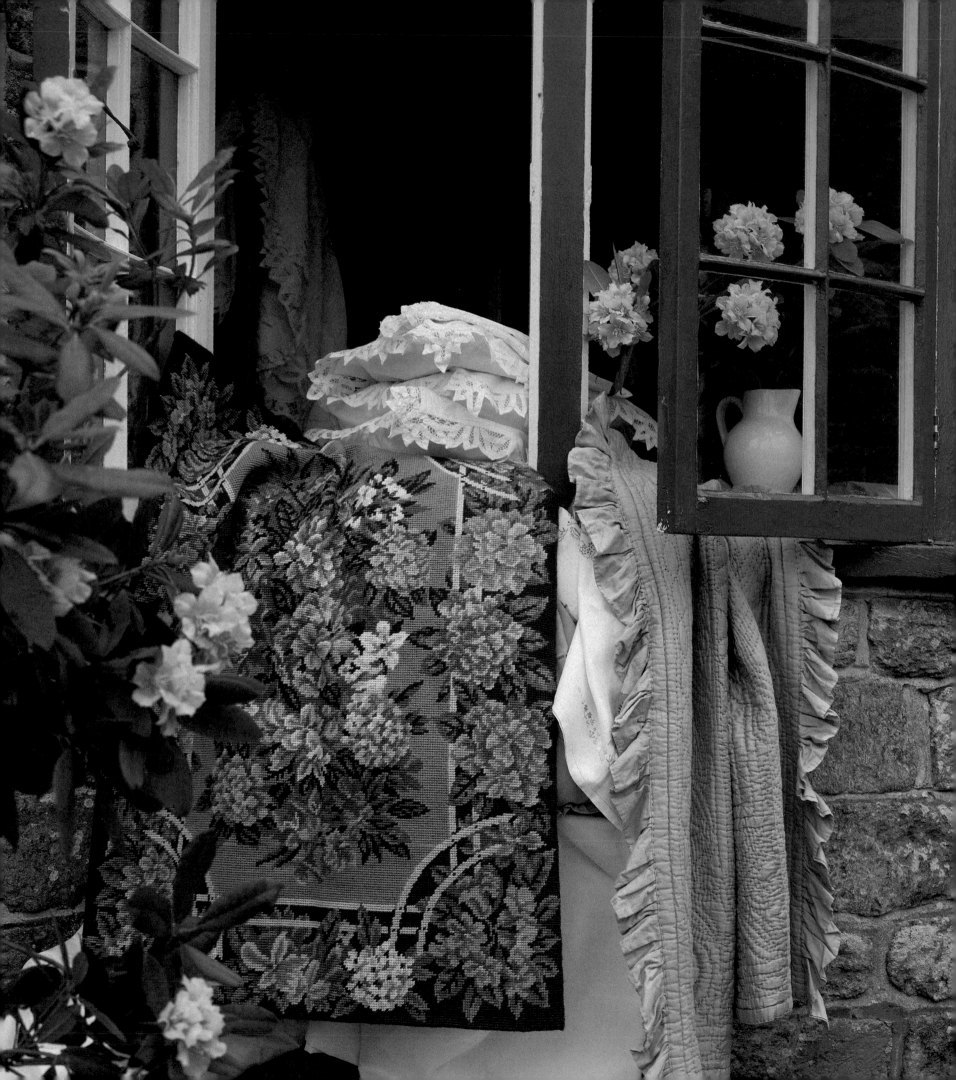

is replicated stitch by stitch on to graph paper with the shade number of each individual stitch recorded. This is then fed, section by section, into a computer which cuts a different stencil for each shade in each section. A rug of this size might have two, or possibly four sections. Once the computer has cut the stencils they are applied individually by hand to the canvas and then painted over. They must align exactly and a hand-printed canvas will always be more exact than a machine-printed one. On a really complicated carpet such as Kaffe Fassett's 'Flower Trellis', well over seven hundred stencils will be required. Production of three canvases a day for a carpet like this is about average and explains the relatively high cost of the kit.

In all types of printing, whether it be hand-printing for rugs or machine-printing for smaller canvases, the colours will be marginally heightened if there is any possibility of confusion. You can appreciate the importance of this when dealing with one of Kaffe Fassett's cabbages with their blends of different greens. In the early days when our designs were simpler we printed the canvases to match as exactly as possible the wool shades. It looked nicer and with a design using only twelve colours there was not much chance of misplacing a wool. Now that we have embarked on subtle shading and close tonal changes heightening the colours on the printed canvas has become a necessity. Sometimes customers will open a kit, look at the canvas and think they have been sent the wrong colourway! Intensifying the colours is the practical reason why, in some of our kits, the printed colours do not match the yarn colours. If you are working on one of these kits my tip is to start off by making your own fringe card. This can be very helpful for complicated designs, particularly when working at night with electric light. All our canvases have colour blocks printed at the side with the shade number for identification. Before you get going stitch the relevant wool into the relevant square and you have your shade card. This works well for Anchor or Paterna wools which come with ball-bands listing the shade numbers. Appleton's wools, unfortunately, come unmarked in cut lengths so the

same procedure has to be followed by a process of elimination.

Nearly all of our wallhangings, cushion covers, stool tops and smaller items are screen-printed. This process is actually called silk screen printing as the gauze used was traditionally silk. As in most manufacturing processes, silk has now been replaced by various man-made fibres. This is a semi-automated process where the human eye and hand are still essential for placing the canvas exactly in position for printing. If a canvas is printed more than three lines out of true you should return it, but a degree of tolerance must be allowed below that. No design will suffer when stitched if the canvas is three holes or less out of true when printed. The uneven nature of canvas makes even more exact precision an impossibility anyway, and the human eye can still judge better than any computerised machinery the best alignment in this inexact science.

It is also the human eye which takes the final decision on the correct colour mix for printing the separate colours. Our canvases are printed with pigment dyes, not inks, and the printers hold recipes for every shade mix. These shade numbers correspond with the shade mixes of the yarns and highly calibrated digital scales are used for colour balancing the recipes. I always enjoy watching the canvases being printed. There is something immensely creative and satisfying about watching a well-executed manufacturing process, and it makes you realise what goes into the production of what must appear a very simple product. Exact matching of dye lots is even more important for wools and both Anchor and Appleton's have a high reputation in this regard.

In the next chapter the importance of accurate dye lots and colour matching is self-evident. Nearly all the pictorial designs depend on detail and colour gradation. Along with those in the final chapter, they come closest to the notion of 'painting with wools' and range over a wide variety of styles. They adapt images directly from nature, as an artist does, and all have a painterly feel to them. They are all representational and direct, letting the subjects speak for themselves.

'Rhododendron Rug' by Margaret Murton (opposite page). A surprisingly simple design for Margaret Murton this rug would go well in a bedroom or study. It is one of our smaller rug kits which has its advantages as many of our larger ones require a real commitment in terms of time and energy.

*'Swiss Chard' by Kaffe Fassett
(opposite page). An unusual
vegetable to choose for a tapestry,
Swiss chard (as its name implies)
is more familiar to continental
Europeans than the British. It has
been consistently grown in this
country since the mid-sixteenth
century but has never been very
popular. We used to eat more of it
in the past. John Evelyn stewed
the leaves of his chard in their
own juices (like spinach) and
served them on buttered toast. In
Europe, Swiss chard is often used
in pork pies to reduce the pie's
fattiness and to add flavour, but in
this country they are grown more
for decoration than for food.
Although fairly immune to pests,
their large leaves are easily
damaged by storms. Their height
makes a useful visual additive to a
kitchen garden.*

*The irregular chequerboard
border and soft repeat pattern of
the background would make good
tapestry compositions by themselves.
Chequerboard patterns are a
hallmark of Kaffe Fassett's work,
particularly in his knitting, and
the combination of variegated
greens and reds works very well
here. An interesting idea would be
to take a corner of this design and
repeat the chequerboard section that
is visible over a larger area of
canvas, multiplied say three or
four times. This should make a
simple geometric design of coloured
squares, and Kaffe's colours are so
good that they would need no
additions or alterations.*

The subject of colour, and particularly how colours
affect each other, is a complex one. When two colours
are juxtaposed they both appear to undergo surprising
changes. When a red is juxtaposed with yellow it takes
on the cast of the colour which is complementary to
yellow – violet – which is composed of the other two
primaries absent from yellow, namely red and blue.
It is helpful to know this when considering how
colours will react together. When you look concen-
tratedly at any isolated colour an after-image appears
before your eyes: green after red, orange after blue,
violet after yellow. This is not a theory, but an easily
demonstrated fact. If you place a small circle of colour
on a white sheet under incandescent light and gaze at
it for a minute you will actually see another coloured
circle emerging from the first like a ghost figure. It
will be the complementary to the original colour and
what is happening is that your eyes are filling in the
colour needed to make white light, which is composed
of red, blue and yellow.

From 1824 to 1883 Michele-Eugene Chevreul was
Director of Dyeing at the famous Gobelins tapestry
works in France. He received a steady stream of com-
plaints that colours used in the Gobelins tapestries
were weak. They were especially concerned about the
'want of vigour' in the black. He was a chemist by
profession and his investigations showed him that the
blacks were exactly the same as those used in the past.
What had changed were the other colours; and set
against the colours then in fashion black looked weak.
He became so intrigued by the subject that in 1835 he
published *The Principles of Harmony and Contrast of
Colours* which forms the basis of much of our present
knowledge of colour interaction.

Last year I heard a talk on the radio by Brian
Sewell, an art critic known for his thought-provoking
assessments and slightly pugnacious manner. He was
discussing the lack of attention paid by art schools to
the teaching of colour. He said that students were no
longer given basic instruction in the facts and theories
of colour combination whereas at the time when he
was an art student this was taken seriously. From what
I understood, in his day students spent time shifting

colours into combinations to learn how they reacted
together. This is an essential exercise for anyone de-
signing in wools. The vast range of colours available
in tapestry wool – over 300 shades in each of the
Anchor and Appleton ranges – means that for any
needlework designer, whether professional or
amateur, experimenting with colour combinations is
one of the keys to success with the craft. The endless
discoveries of how colours interact, the fascination
with colour changes and their effects on each other is
the hallmark of Kaffe Fassett's work and his 'Swiss
Chard' opposite is as good an example as any of his
determination to push these discoveries further and
further.

In the 1860s when Manet and his followers' depic-
tions of nature abandoned soft, naturalistic shadings
in favour of strong, harsh contrasts, Paris was out-
raged. In 1863 his work was rejected by the official
exhibition called the Salon and was shown instead at a
show entitled 'Salon of the rejected', where the public
went for an outing to have a good laugh. What the
Impressionists had discovered, we now realise, is that
if you look at nature you do not see individual objects
each with their own colour but what the art historian
E.H. Gombrich described as 'a bright medley of tints
which blend in our eye or really in our mind'. The
colours of this Swiss Chard are clearly in Kaffe Fas-
sett's mind. You won't find many of these irradiated
shades in a greengrocers. But that is exactly the point.
By depicting fruits and vegetables in a mixture of
representational and unnaturally heightened colour he
brings an artist's eye to his subject, emphasising con-
trasts that he sees and bringing his own spirit into the
work. We have a small but steady correspondence
with customers who dispute the shading of his plums
or apples and we have to point out that this is the work
of an artist not a botanical photographer. It is in-
teresting how people can accept unnaturally coloured
figures, skies or buildings in art more readily than
fruits or flowers.

'Swiss Chard' proved much more popular in
America than in Britain. It was commissioned from
us by Smith and Hawken, the dynamic Californian

A detail from a floral oil painting (below) on copper by Daniel Seghers (1590-1661). These combinations and bouquets of flowers were aesthetic constructions, composed from illustrations rather than actual observation. The little animals which often appear in these paintings – dragonflies, caterpillars and the like – are drawn with as great a delicacy as the flowers.

mail-order company, and I was pleased by its immense success. It illustrates the variations in taste to be found in different countries. In my experience, New Zealanders are fairly like the British in their taste, whereas the Australians prefer brighter colours. The French like anything to do with animals, particularly Candace Bahouth's medieval series which featured in our last book, *Noah's Ark*. The Italians favour a chic, interior decorator's style, and the Scandinavians a mixture of soft, sophisticated patterns along with splashes of colour. But in every country we export to, without exception, there is a strong following for Kaffe Fassett's work.

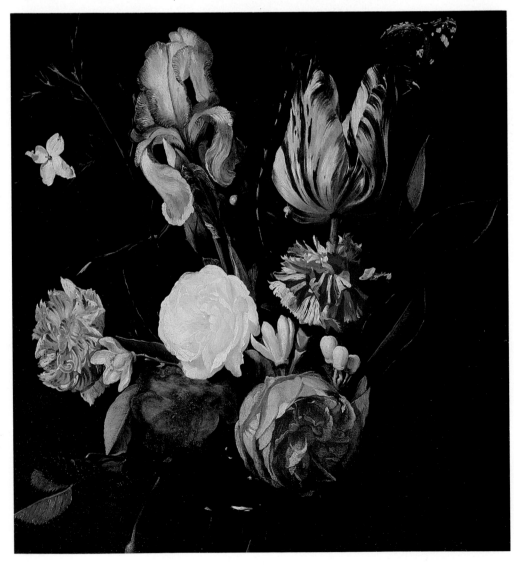

We only realised the extent of this international following after the exhibition in 1988 at the Victoria and Albert Museum in London. It was Kaffe's idea to turn this exhibition into a travelling one. Museums around the world were approached and Scandinavia was most receptive. The exhibition's first showing abroad was in Copenhagen, where it attracted over 70,000 visitors; and this was followed by Stockholm where over 100,000 people attended. This was quite astonishing. The museum in Stockholm was the Swedish national museum for the decorative arts and, in terms of attendance figures, the Kaffe Fassett show was the most popular they had mounted since the First World War. It had to be extended for a week due to popular demand. On its final day it even got a small slot on the evening television news where they showed queues stretching out of the museum and over the nearby bridge. None of us expected anything like this and I remember being amazed at the numbers of posters of Kaffe all over Stockholm at the time – like a visiting pop star. Last year the exhibition went to Oslo where over 50,000 people turned up – a remarkable success considering the size of the Norwegian population. Scandinavia has a large number of dedicated knitters but there was also a tremendous interest in his tapestries, although there is only a limited Scandinavian tradition of working from printed canvases.

I mentioned Candace Bahouth and in this chapter we see the first examples of her work. She is a weaver by profession, producing large-scale hangings to commission. Her artistic interests have taken her into many other fields from garden furniture to painting but I am delighted that her current passion is needlework design. The subject material for her woven tapestries has been eclectic over the years, from Red Indians to Punk Rockers, but she has always felt an empathy with the woven fabrics of the past, whether European or Eastern. She draws on this knowledge for many of the tapestry designs she has done for us, most noticeably her medieval series, but here her source of inspiration is pictorial – those wonderful seventeenth-century Dutch still-lifes of tulips.

'Pale Stripey Tulips' by Candace Bahouth (left) *and her darker version* (below) *are two separate designs, not different colourways. The paler version captures the fluid, almost languid shape of the flower while the darker version pays attention to the vibrant colour combinations of the petals.*

'Stripey Tulips' is an interestingly shaped cushion, being taller than it is wide which is unusual. Nearly all our cushions are square or rectangular. The dark colourway was the first Candace produced. In the majority of Dutch still-life paintings the fruits and flowers shine out from black backgrounds. Candace has chosen a navy blue but the rich effect is the same. She then decided to try it with a paler background and sensibly used variegated shades of the lighter blue to produce a subtly mottled effect. The flat colour of the navy works well but a flat paler blue would have looked insipid. Candace was the first designer we worked with to introduce this mottled shading for backgrounds. It is almost like bargello in feel but less obvious and is a perfect substitute for a single coloured background when you are working a simple, graphic design. An early example of this technique of hers can be seen on page 94 where 'Flowing Flower' is shown. This creates the illusion of age as it looks as though a single colour has faded irregularly in different places, which softens the appearance of the tapestry. Candace's skill as a painter can be appreciated in the working of her tulips which are beautifully drawn and coloured. Like so much of her work, it is simple and elegant and would look good in a wide variety of settings. It could, for example, make an interesting small wallpanel.

Candace is another American, from New York originally and now living in Somerset. Despite the tranquillity of her rural surroundings her work retains a stylish, cosmopolitan flavour. Last year she produced leopardskin and tigerskin cushions, cleverly capturing the patterns and colours of the real skins, which are probably more popular with interior decorators than needleworkers as they are fiendish to work, and her designs are much admired in Italy and France. The variety of her tapestries is tremendous and the sign of a really creative designer. The leopardskin cushions are quite different from her tulips, or again from her millefleurs designs, two of which

SUTTON'S "ROYAL JUBILEE" PEA.

This picture from an old Sutton's seed catalogue (above) *inspired Kaffe Fassett's 'Peas'* (opposite). *One of the oldest crops on earth (as old as wheat or barley) peas were introduced to Britain by the Romans. In the eighteenth and nineteenth centuries early peas were considered a great delicacy with overwintered seedlings being transferred to hotbeds in February.*

are featured in this book on pages 89 and 111. It is hard to categorise her work as it crosses so many boundaries but her use of colours and the overall feel of her tapestries is immediately recognisable. She is embarking next on a large tigerskin patterned rug, inspired by the tiger rugs of Tibet.

Botanical prints and drawings are manna to needle-workers searching for new ideas. These drawings and paintings, usually of individual plants or flowers, were not undertaken as artistic exercises but as practical scientific records. The skill and artistry of their execution, however, give them a distinctive decorative

appeal and in this area it is hard to distinguish between art and science. Neither Leonardo nor Dürer were artists motivated by botanical aims but Dürer's famous *Iris* was almost a textbook illustration for a much later work on the genus Iris, so well understood is the form structure and texture of the plant. The most beautiful botanical pictures of all by Redouté and Ehret are also exact specimen representations. Here is the beauty of nature presented, unembellished, in its purest form. A modern equivalent might be the stunning flower photographs of Steve Lovi, the ones where there is no setting or addition of props, simply the flowers themselves. Alexander Marshall's flower studies, Dodart's history of plants illustrated by Nicolas Robert, the more composed flower paintings of Jan Van Huysum or Hooker's famous botanical series would provide inspiration for ages. In these works you will also see exquisite paintings of vegetables and fruits and Kaffe Fassett has studied them for many years. His 'Peas Cushion' on page 69, curiously enough, was inspired by a picture in a Sutton's Seed Catalogue!

Kaffe Fassett's vegetables have probably become his most widely admired needlework achievement. His cabbages and cauliflowers were for a time almost like a *nom de plume*. Their classic botanical depiction, their modulated and subtle blends of fresh green, the simplicity and directness of their design, not to mention their sheer originality, bowled everyone over. They appeared, like so much of his best work, in *Glorious Needlepoint*, a book which influenced the field of interior decoration for at least a year afterwards, with fruits in particular featuring strongly in fabrics produced by a wide range of companies. We have not included any material from that book here, as you will nearly all have seen it before, but 'Peas' follows in the tradition of his 'Cabbage' and 'Cauliflower', and in their different way make an equally strong tapestry. Green, once again, is used almost to the exclusion of any other colour. The cabbage and cauliflower had their mauve backgrounds and the peas have their blue and white sky, but otherwise all is a sea of fresh green.

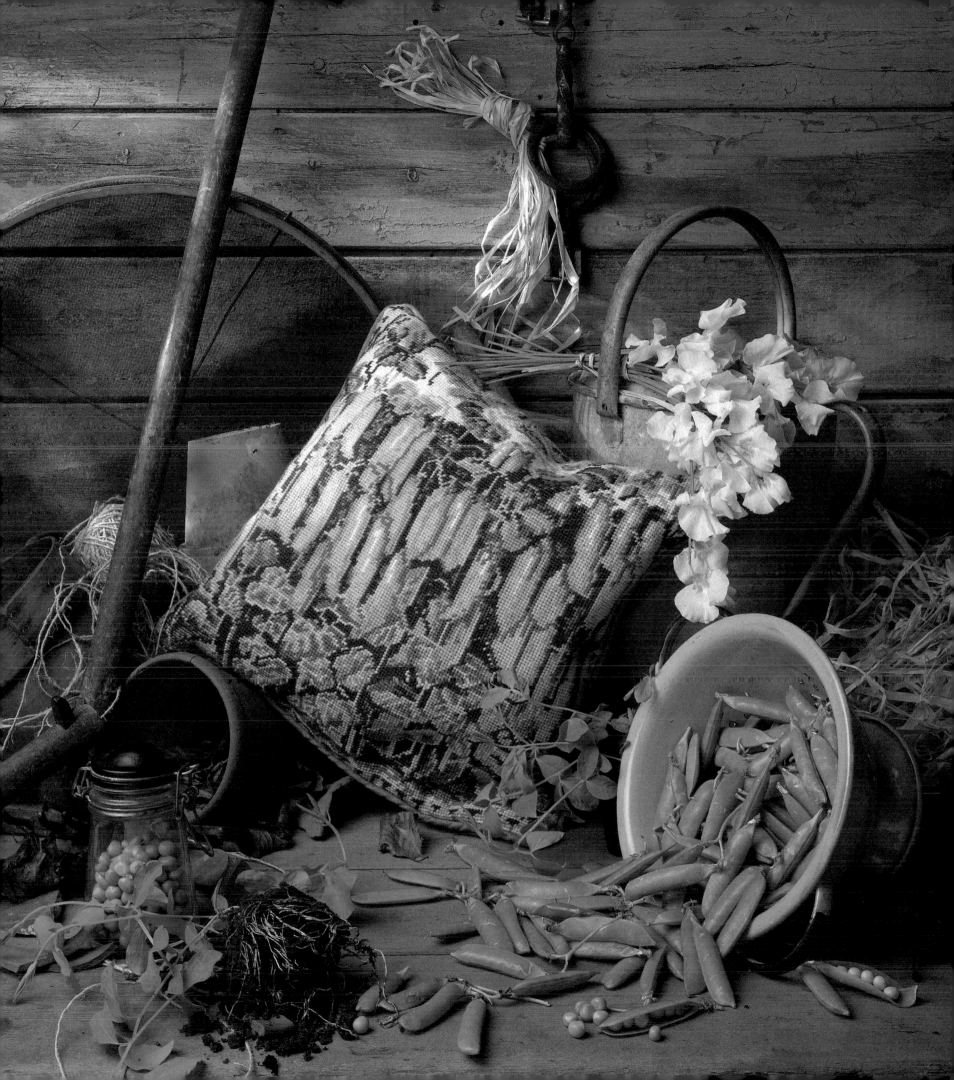

PEAS
by Kaffe Fassett

Kaffe Fassett's 'Peas Cushion' was inspired by a picture in a Sutton's Seed Catalogue. His vegetables have probably become his most widely admired needlework achievement. His cabbages and cauliflowers were for a time almost like a nom de plume. *Their classic botanical depiction, their modulated and subtle blends of fresh green, the simplicity and directness of their design, not to mention their sheer originality, bowled everyone over.*

MATERIALS
Tapestry wool (see Colourways). The amounts given are for tapestry wool worked in basketweave or continental tent stitch. If the design is worked in half-cross stitch, 30 per cent less wool is required. Double-thread or interlock canvas is suitable for all three types of tent stitch, but if basketweave or continental tent is used an ordinary mono canvas may be substituted. Three strands of Persian wool or four strands of crewel can be substituted for the single strand of tapestry wool used for this design. (To calculate amounts for crewel or Persian wool see page 113.)
10-mesh double or mono interlock canvas 50cm (20in) square
Size 18 tapestry needle
50cm (20in) furnishing fabric for backing
1.8m (2yd) narrow piping cord
Cushion pad (pillow form) 40cm (15½in) square
30cm (12in) zip fastener (optional)
Scroll or stretcher frame (optional)
Tools and materials for preparing canvas (see page 114) and for blocking (page 115)

The finished cushion measures 40cm (15½in) square and is worked on 10-mesh canvas.

WORKING THE EMBROIDERY
Prepare the canvas and mount it on the embroidery frame, if used (see pages 114 and 115).

Following the chart on the right and using a single strand of tapestry wool, work the design in basketweave or continental tent stitch, or in half-cross stitch.

BLOCKING AND MAKING UP
Block the completed work (see page 115) and allow it to dry thoroughly. Trim the canvas edges, leaving margins of 2cm (¾in).

From the backing fabric cut a piece 44cm (17in) square. Or, if inserting a zip, cut two pieces as specified on page 116.

From the remaining fabric, cut and join bias strips to cover the piping cord (see page 117). Make up the piping.

If using a zip, insert it in the back cover (see page 116).

Attach the piping to the back cover as described on page 117.

Join the front and back covers as described on page 117, and insert the cushion pad.

COLOURWAYS AND YARN AMOUNTS
The cushion cover pictured was worked in Anchor tapestry wool. DMC tapestry wool colours are given as an alternative; you should note, however, that colours in an alternative brand of yarn will only provide approximate equivalents.

- 64m (70yd) of Anchor 0218 (or DMC 7389)
- 27m (30yd) of Anchor 0861 (or DMC 7385)
- 50m (55yd) of Anchor 0216 (or DMC 7320)
- 43m (47yd) of Anchor 3149 (or DMC 7911)
- 24m (27yd) of Anchor 0569 (or DMC 7604)
- 48m (53yd) of Anchor 0242 (or DMC 7771)
- 64m (70yd) of Anchor 0240 (or DMC 7772)
- 12m (13yd) of Anchor 0420 (or DMC 7489)
- 12m (13yd) of Anchor 0378 (or DMC 7465)
- 15m (17yd) of Anchor 0144 (or DMC 7715)
- 18m (20yd) of Anchor 0402 (or DMC white)

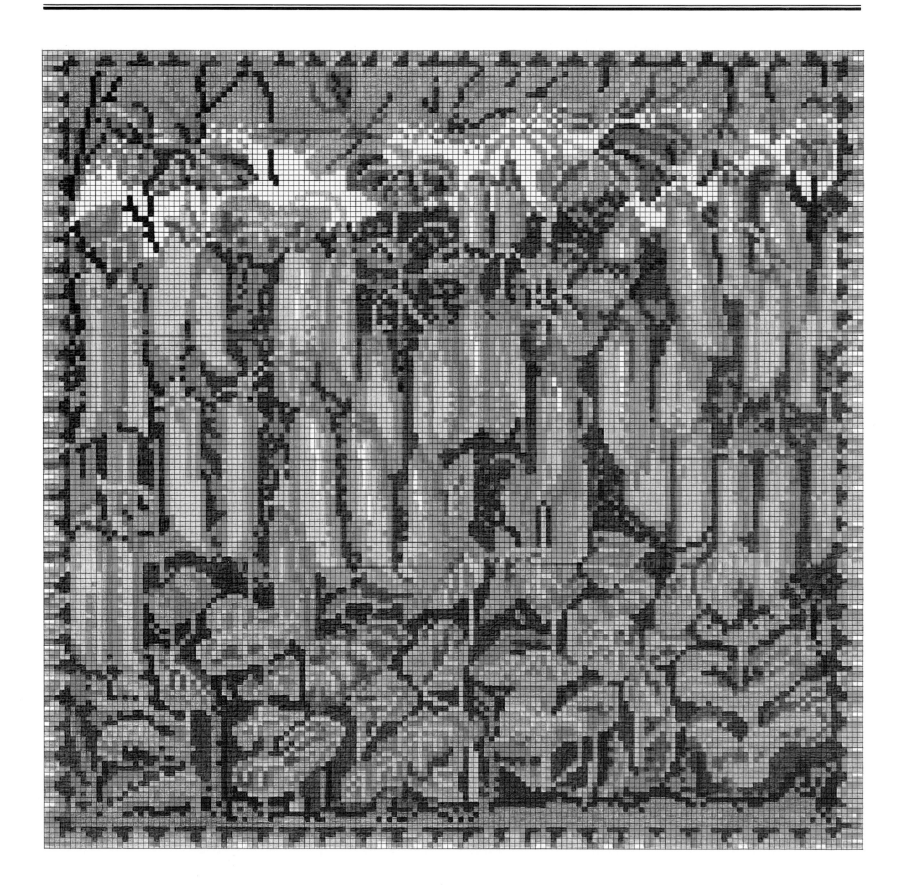

'Pansies Panel' by Elian McCready with Kaffe Fassett (right). *The most dramatic design in this book, Elian's pansies are a blaze of saturated colour.*

Working in Kaffe Fassett's studio, helping with his large tapestry commissions or with his spectacular knitwear, is a loose group of associates who come and go but who, over the years, have developed into a fantastic team. One of these is Jill Gordon, mentioned earlier, and another is Elian McCready. Elian is probably the most permanent of them all and has been involved in most of Kaffe's major projects over the last six or seven years. Like all the other members of this group she is a designer in her own right and all of their own work has blossomed in recent years by working in such a stimulating and creative environment. Inevitably, both Jill's and Elian's designs are influenced by Kaffe's use of colour and the colours in both the 'Russian Tapestry' and the 'Pansies Hanging' on pages 31 and 72 are some of the most dramatic and exciting in this book. In fact, the 'Pansies Hanging' is one of the highspots of this book. Kaffe often takes it to show audiences when he does his lecture tours and it usually causes as much of a stir as his own designs. The saturated richness of colour and the bold, fearless scale of the flowers make a tremendous combination and there is no fussy patterning to detract from its visual power. We have photographed it in this minimalist surrounding and it would look just as good on a stone, wood or brick surface as it does on a plain painted wall. It is stitched, like the 'Begonias Panel' on page 109, in random long stitch which makes it quicker to complete and gives an interesting texture. The canvas for this kit is worked in strands of single colour but when working on commissions Kaffe, Elian and Jill will mix colours to achieve ever more subtle shading. The more adventurous of you may wish to try this yourselves. Elian's next design for us is a panel of tulips, to the same size and scale, and I can't wait to see it. Panels and wallhangings are becoming increasingly popular and we hope to expand our range considerably over the next two or three years.

Smaller pictures have always been very popular and the best of them double quite comfortably as cushions. Edwin Belchamber's 'Gateway' is a good case in point. Designed originally as a picture, in fact as one of a series of pictures of English gardens, we have photographed it here as a cushion, and I actually prefer it used in that way. It has a strong graphic power mellowed by the delicate outlines of the wrought ironwork and the climbing shrubs. The restrained use of greens, brick and biscuit browns and the soft honeysuckle border suit the subject matter very well but its real strength is its clear use of perspective. Looking through the gate you know exactly how long this garden is and the use of only three shades of green to delineate the shadows of the trees is masterful. It will come as no surprise to learn that it is the work of a graphic artist.

'The Gateway' by Edwin Belchamber (below). *The eighteenth-century revolution in English landscape gardening, from classical to romantic, no longer regarded nature as subservient to man. But the perspective and proportion of Renaissance Italy was not abandoned altogether and the three basic ingredients of garden construction remained the same: stone, trees and water. The colours of these elements are reflected in this tapestry.*

GATEWAY
by Edwin Belchamber

Edwin Belchamber's 'Gateway' has a strong graphic power mellowed by the delicate outlines of the wrought ironwork and the climbing shrubs. The restrained use of greens, brick and biscuit browns and the soft honeysuckle border suit the subject matter very well but its real strength is its clear use of perspective. Looking through the gate you know exactly how long this garden is and the use of only three shades of green to delineate the shadows of the trees is masterful.

MATERIALS
Tapestry wool (see Colourways). The amounts given are for tapestry wool worked in basketweave or continental tent stitch. If the design is worked in half-cross stitch, 30 per cent less wool is required. Double-thread or interlock canvas is suitable for all three types of tent stitch, but if basketweave or continental tent is used an ordinary mono canvas may be substituted. Two strands of Persian wool or three strands of crewel can be substituted for the single strand of tapestry wool used here. (To calculate amounts for crewel or Persian wool see page 113.)
12-mesh double or mono interlock canvas 50cm (19in) square
Size 18 tapestry needle
50cm (19in) furnishing fabric for backing
1.7m (2yd) narrow piping cord
Cushion pad (pillow form) 37cm (14½in) square
25cm (10in) zip fastener (optional)
Scroll or stretcher frame (optional)
Tools and materials for preparing canvas (see page 114) and for blocking (page 115)

The finished cushion measures 37cm (14½in) square and is worked on 12-mesh canvas.

WORKING THE EMBROIDERY
Prepare the canvas and mount it on the embroidery frame, if used (see pages 114 and 115).

Following the chart on the right and using a single strand of tapestry wool, work the design in basketweave or continental tent stitch, or in half-cross stitch.

BLOCKING AND MAKING UP
Block the completed work (see page 115) and allow it to dry thoroughly. Trim the canvas edges, leaving margins of 2cm (¾in).

From the backing fabric cut a piece 41cm (16in) square. Or, if inserting a zip, cut two pieces as specified on page 116.

From the remaining fabric, cut and join bias strips to cover the piping cord (see page 117). Make up the piping.

If using a zip, insert it in the back cover (see page 116).

Attach the piping to the back cover as described on page 117.

Join the front and back covers as described on page 117, and insert the cushion pad.

COLOURWAYS AND YARN AMOUNTS
The cushion cover pictured was worked in Appleton tapestry wool. DMC tapestry wool colours are given as an alternative; you should note, however, that colours in an alternative brand of yarn will only provide approximate equivalents.

- 58m (63yd) of Appleton 406 (or DMC 7890)
- 43m (47yd) of Appleton 545 (or DMC 7988)
- 15m (16yd) of Appleton 252 (or DMC 7583)
- 14m (15yd) of Appleton 841 (or DMC 7905)
- 43m (47yd) of Appleton 761 (or DMC 7511)
- 19m (20yd) of Appleton 302 (or DMC 7465)
- 14m (15yd) of Appleton 955 (or DMC 7514)
- 11m (12yd) of Appleton 222 (or DMC 7215)
- 9m (9yd) of Appleton 159 (or DMC 7429)
- 15m (16yd) of Appleton 461 (or DMC 7715)
- 23m (25yd) of Appleton 991 (or DMC écru)

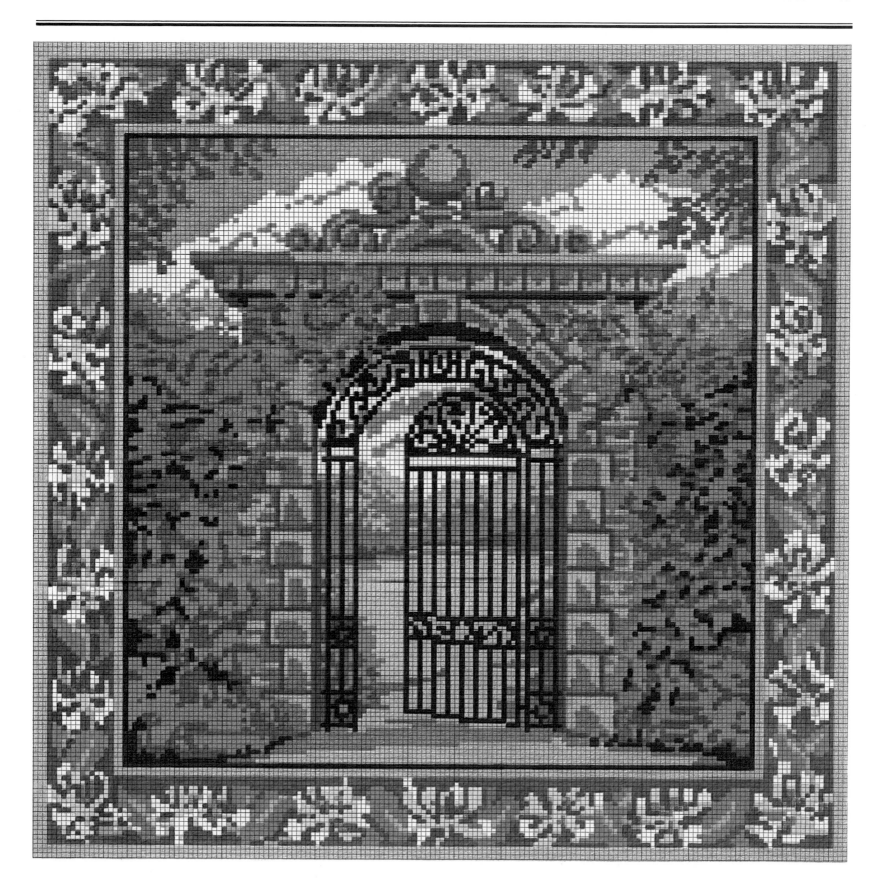

Edwin has for many years drawn our tapestries in black and white for use in our newspaper advertisements. This may seen an extraordinary way to go about selling a product which largely depends on colour but it seems to work. The way the tapestry is drawn is all important as it must convey a sense of texture. Edwin has proved an expert at developing this style of drawing and between us we grew to recognise certain types of design that would translate better into black and white drawings than others. As an experiment he decided to design a tapestry starting as a black and white drawing and adding colour later – designing in reverse. His love of gardens and his graphic designer's keen eye for perspective led to the creation of 'Walled Garden', the first of his garden series and one of our most popular designs ever. 'Gateway' is the third of four and all have similar colours and surrounding borders.

The last two designs, 'Irises' and 'Tulips', in this chapter are both by Kathleen McKenzie and are both pictorial in different ways. The irises are in the botanical tradition, taking a single flower, examining it from different angles and using the shapes of this single motif to create an overall design. The basket of flowers takes a well-known and much loved standard composition from paintings of the past and translates it directly into needlework. Both of them have that restrained, classical feel which is the hallmark of her work and both would be easy and comfortable to live with. Kathleen's sharp use of colour adds a sparkle to both which is refreshing. So many designs of this type are spoilt by dreary, depressing colours which are a legacy from the Victorian age. Kathleen's fresher colours are from an earlier era. The piquant, lively colours common to all branches of the decorative arts in the late eighteenth and early nineteenth centuries

'Basket of Flowers' by Kathleen McKenzie (right). *Numerous compositions similar to this one have appeared in all forms of the decorative arts for hundreds of years and we never tire of them. (See the illustration, for example, on page 38 of the eighteenth-century porcelain flowerpiece from the Wallace Collection.) This design could be placed on a number of different backgrounds, and it would be interesting to substitute the plain colour for soft stripes. When choosing a different colour for the background make sure none of the wools used in the composition itself are too close in tone; otherwise there are no fixed rules. You will always have to stitch a section of canvas before making a final decision on which shade you are going to use, as tapestry wools, when worked over an area of canvas, almost invariably come up darker than you expect.*

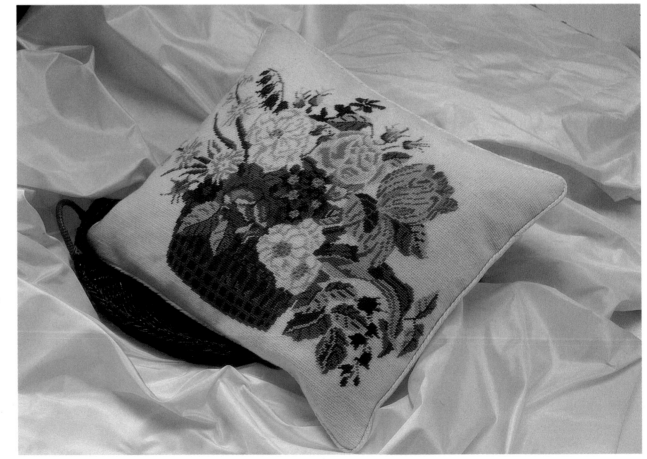

have been rediscovered this century. The Victorian colours that came between had a commendable clarity and strength in some cases; but on the whole their colours were heavy and vulgar with a depressing weight of dullness that we are well rid of. The Arts and Crafts movement was as much a rebellion against Victorian colour as design.

Painting, gardening and needlework often go together. As Elizabeth Benn said in *Noah's Ark*, 'There is a recognised affinity between gardening and embroidery. Keen gardeners who turn to embroidery in the winter say it is their "indoor gardening".' There is an equally strong link between gardening and painting: flowers, gardens and landscapes are the most popular subjects for watercolours. The pictorial tradition of needlework design, particularly in connection with flowers, fruits, leaves and nature in general, is long and deep rooted. The shapes and colours of nature need little adaptation when transferred to canvas. They speak for themselves.

All the designs in this chapter are pictorial representations and their directness and simplicity is their strength. In the next chapter, by complete contrast, you will see patterns galore.

'Irises' by Kathleen McKenzie (right). This design grows on me. The mottled background softens the bold outline of the individual irises and uses the same technique of blending two tones of background colour which we find in many of Candace Bahouth's designs.

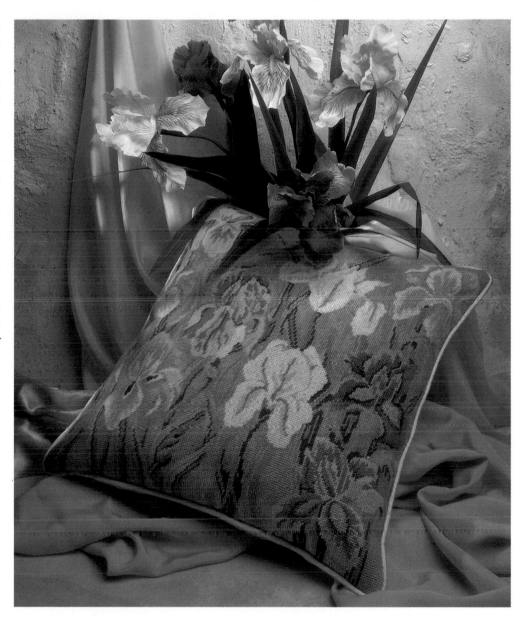

TEXTILES

The influence of textile patterns, both from East and West, has shown up again and again in the work of our designers. There were examples of this in the first chapter and also in the chapter on pattern repeats. These were mainly influenced by the fabrics of Western Europe but in this chapter we have a group of Kaffe Fassett's designs which are directly inspired by those of the East and, in particular, by carpets and rugs. The colours of 'Night Tree', 'Carpet Garden', 'Ribbon and Rose' and 'Tropical Flowers' could hardly be more dissimilar but they all use the patterns found in Eastern textiles. Kaffe's first design for Ehrman was called 'Caucasian Flower' which was followed by 'Esfahan Rose', 'Baroda Stripe', 'Turkish Lace' and then 'Carpet Garden'. The names of these tapestries tell the story and although the influence of the East has been less prevalent in his work lately it is a continuing theme. The 'Ribbon and Rose Cushion' was stitched only last year.

We usually think of Eastern carpets as being Persian. Curiously enough, carpets represented in European paintings of the fourteenth, fifteenth and sixteenth centuries were mainly from Anatolia and were called 'Turkey-Carpets'. Persian carpets, primarily because of transport difficulties, were not seen in Europe until later. The Anatolian carpets with their bolder designs and heavy use of earthy reds and indigo were probably nearer in style to the original nomadic carpets of Central Asia which were used as roofs for tents, saddles for horses and blankets for beds as much as floor coverings. In European paintings carpets are often shown as table coverings. In Marco Polo's opinion 'the finest and handsomest carpets in the world are made in Turkomania'. The patterning was cruder and livelier than the more polished, complex and sophisticated carpets produced by the settled populations of Persia. In the 1960s the hippy trail snaked through Iran and Afghanistan towards Nepal and back along it came all forms of woven textiles from that part of the world – rugs, hats, slippers, saddlebags and belts. Much of the basic pattern and colour of these items had changed little since Marco Polo's day and it reawakened a new interest from the West. In the group of Kaffe Fassett tapestries shown on pages 79 to 87 there is no trace left of the soft 'ethnic' colouring of the originals but the patterns are the same timeless patterns, repeated over many centuries, that are found in so many of the textiles of Central Asia and the Near East. They have all been given the unique Kaffe Fassett colour treatment and the colours reflect the period in which they were designed, the 1980s not the 1960s. Kaffe retains in all of them the vibrant and asymmetrical boldness that gave the originals such incredible vigour. He is alone among tapestry designers in appreciating that the power of these rugs and carpets lies in their irregularity. He never straightens up an edge or juggles a composition into a neater format but uses the strength of these rough outlines as vehicles for his colour. The designs themselves are cleverly balanced compositions which manage to condense the spirit of these larger textiles into standard-sized cushions. They all, I think, manage to convey his love for this type of work.

'Carpet Garden' by Kaffe Fassett (below). Reminiscent of Indian Mughal floral painting but also of the woven rug patterns from Central Asia. Carpets made by these nomads and tribeswomen have the character of folk music. The pattern, like a folk song, is not written down anywhere and is kept alive by direct transmission from person to person. In this instance the young girls of the tribes are taught how to weave the pattern by their mothers.

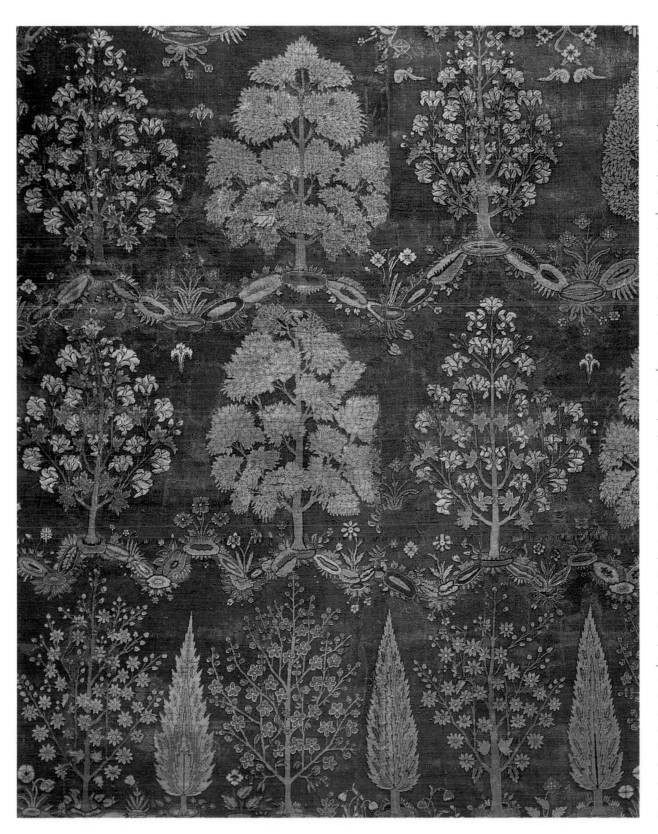

'Tree of Life' (left), *a carpet dating from the early seventeenth century in the Frick Collection, New York. The soft pinks and greens on the claret-red ground are a beautiful combination of colours. Trees, with their special significance to the inhabitants of the dry lands of Islam, regularly feature in eastern carpets and textile designs. This particular example came from the shrine of the holy city of Ardebil in Iran. The heavy motifs of the trees are lightened by the flowers adorning them and by the lotus blossoms and tulips brightening the flower beds.*

 This carpet could not have found a better home. The Frick Collection, housed in a mansion built by the late nineteenth-century American tycoon on the upper east side of Central Park in New York, is one of the few truly great art collections in the world. It reflects the near perfect taste of its creator. Covering a wide variety of fine and applied art, from early Italian to impressionist painting, sculpture, furniture and textiles, every item is selected with thought and precision. Although the collection is extensive it is manageable and stretches through a series of spacious, light rooms flanking a long central pool. Displayed in this way the works of art are more immediately accessible than in a museum and an afternoon spent at this house is a wonderful restorative for the aesthetic batteries. It is also a haven of calm in the middle of New York and not to be missed for that reason alone.

CARPET GARDEN
by Kaffe Fassett

The influences of Hindu art on the world of Islam and vice-versa are well chronicled and in 'Carpet Garden' the two are fused. The six single stylised flowers are reminiscent of the painted borders of Indian manuscripts or Mughal floral miniatures, whereas the thin border of rough pattern give the cushion the textural feel of Eastern carpets. Each of the six single floral motifs could be repeated to form separate patterns by themselves.

MATERIALS

Tapestry wool (see Colourways). The amounts given are for tapestry wool worked in basketweave or continental tent stitch. If the design is worked in half-cross stitch, 30 per cent less wool is required. Double-thread or interlock canvas is suitable for all three types of tent stitch, but if basketweave or continental tent is used an ordinary mono canvas may be substituted. Three strands of Persian wool or four strands of crewel can be substituted for the single strand of tapestry wool used for this design. (To calculate amounts for crewel or Persian wool see page 113.)

10-mesh double or mono interlock canvas 55cm (21in) square
Size 18 tapestry needle
55cm (21in) furnishing fabric for backing
1.9m (2yd) narrow piping cord
Cushion pad (pillow form) 42cm (16½in) square
30cm (12in) zip fastener (optional)
Scroll or stretcher frame (optional)
Tools and materials for preparing canvas (see page 114) and for blocking (page 115)

The finished cushion measures 42cm (16½in) square and is worked on 10-mesh canvas.

WORKING THE EMBROIDERY

Prepare the canvas and mount it on the embroidery frame, if used (see pages 114 and 115).

Following the chart on the right and using a single strand of tapestry wool, work the design in basketweave or continental tent stitch, or in half-cross stitch.

BLOCKING AND MAKING UP

Block the completed work (see page 115) and allow it to dry thoroughly. Trim the canvas edges, leaving margins of 2cm (¾in).

From the backing fabric cut a piece 46cm (18in) square. Or, if inserting a zip, cut two pieces as specified on page 116.

From the remaining fabric, cut and join bias strips to cover the piping cord (see page 117). Make up the piping.

If using a zip, insert it in the back cover (see page 116).

Attach the piping to the back cover as described on page 117.

Join the front and back covers as described on page 117, and insert the cushion pad.

COLOURWAYS AND YARN AMOUNTS

The cushion cover pictured was worked in Anchor tapestry wool. DMC tapestry wool colours are given as an alternative; you should note, however, that colours in an alternative brand of yarn will only provide approximate equivalents.

- ■ 45m (50yd) of Anchor 045 (or DMC 7110)
- ■ 15m (17yd) of Anchor 068 (or DMC 7194)
- ▧ 30m (33yd) of Anchor 0892 (or DMC 7121)
- ■ 110m (120yd) of Anchor 0700 (or DMC 7875)
- ▨ 15m (17yd) of Anchor 0313 (or DMC 7742)
- ▧ 60m (66yd) of Anchor 0366 (or DMC 7171)
- ▨ 30m (33yd) of Anchor 0215 (or DMC 7384)
- ▨ 30m (33yd) of Anchor 0185 (or DMC 7598)
- ■ 15m (17yd) of Anchor 0122 (or DMC 7798)
- ▨ 45m (50yd) of Anchor 0159 (or DMC 7800)
- □ 15m (17yd) of Anchor 0386 (or DMC écru)

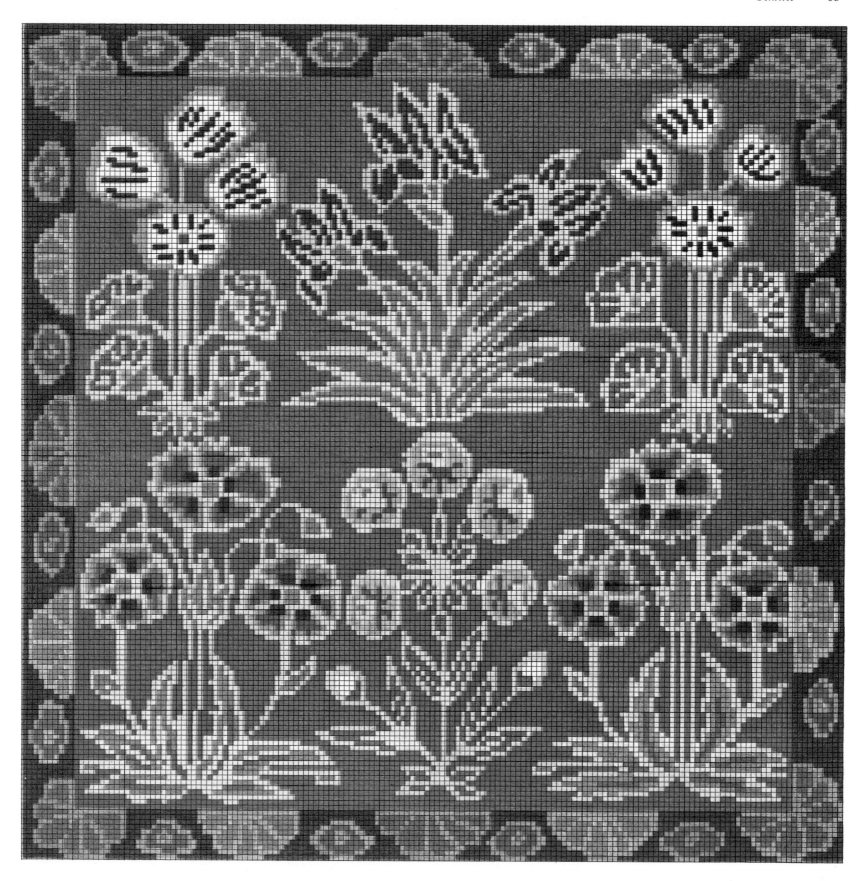

In the lands of Islam water is king. It is no coincidence that many Arab national flags have green in them. The oldest Persian carpet designs depict in abstract form flower beds or gardens irrigated by water channels. Trees, flowers and the produce of nature have a special significance for people who live in or near deserts and in the teachings of the Koran water and gardens are closely associated with the vision of paradise. Islamic art has always accorded a special significance to flowers, trees and gardens and some of the most beautiful floral painting and embroideries ever made come from this part of the world. The influences of Hindu art on the world of Islam and vice-versa are well chronicled and in 'Carpet Garden', shown on page 80, the two are fused. The six single stylised flowers are reminiscent of the painted borders of Indian manuscripts or Mughal floral miniatures, whereas the thin border of rough pattern gives the cushion the textural feel of Eastern carpets. It is one of Kaffe Fassett's most successful and pleasing designs but when it first came out its orange background caused quite a shock. We are all so familiar with it now it seems extraordinary that it should have appeared so bold but it is another example, I suppose, of Kaffe's designs being 'ahead of their time'.

This is a perfect tapestry for adapting if you prefer to work your own designs. Each of the six single floral motifs is a design in itself. They could be repeated to make a much larger rug or adapted for an infinite number of purposes. It is one of the reasons we chose 'Carpet Garden' as a design to chart in this book. This is one of the tapestries Kaffe did for Ehrman in the days when we restricted him to twelve colours and, working within these limitations, it shows what a talent he has for making unexpected and inventive choices. Few people would think of combining the orange background with a burgundy border. The choice of orange is a masterstroke and perfectly complements the fresh, light shades of the flowers. It is warm and cheerful but much lighter in flavour than a traditional textile design and is one of his best.

Another great design from that period is 'Night Tree', shown opposite, which caused an equal stir when it was produced as a kit. The rough, abstract outlines of the design were considered by many to be too indistinct and too avant-garde for our poor customers to manage. Our poor customers managed perfectly well! It had an instant appeal and has remained a firm favourite ever since. It was also one of the first designs to use black as a background. Again, when you see the overuse of black as a background in so many kits today this seems extraordinary, but black was felt to have bad connotations and, for some strange reason, was almost taboo. The mixture of glowing and sludgy autumnal colours set against the black, with the jagged border in colour sections make 'Night Tree' another of my favourites and I am delighted to include it here. 'The most difficult task in the world of art is to draw a tree. Any picture has to leave out most of the detail, to the point of being a caricature; the skill lies in knowing which details are essential,' wrote Oliver Rackham. 'Night Tree' is one of the most abstract of Kaffe's designs and it illustrates his skill as a painter and draughtsman as well as a colourist. Its outline has a courageous boldness few of our other designers would have attempted and it liberated many to experiment with less formal designs for needlework.

Trees have always played a special role in the arts of India. The hallmark of a good king was one who planted trees along the sides of roads to provide shade from the fierce Indian sun. The tree is an even more important symbol to Buddhists. In the seven weeks after the Buddha gained enlightenment a series of events occurred, all of which involved trees in one way or another. To a Buddhist trees have spirits, they are objects of contemplation and they represent life. Trees have a great topical significance to all of us in the West today with our recently acquired knowledge of the significance of the ozone layer and its problems. The destruction of the tropical hardwoods is a tragedy, serving no useful purpose, and equally sinister is the poisoning of the forests of Central Europe. As far as Britain is concerned, I hope the worst is over. It is impossible for us to guard against the freak

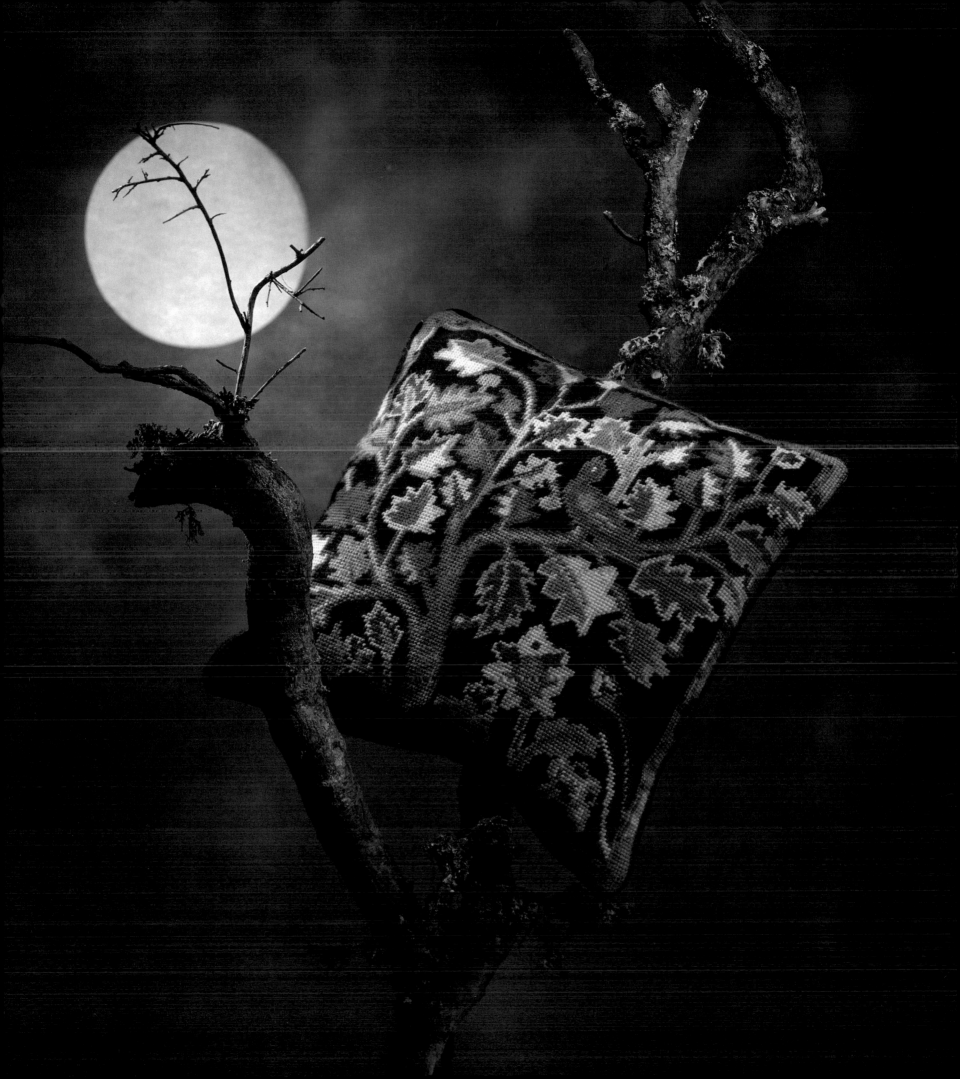

'Ribbon and Rose' by Kaffe Fassett (opposite page). Geometric pattern with flowers is a typically eastern combination; but the flowers in this tapestry are European. Kaffe loves to take patterns from around the world and drop them into a vat of unexpected dye. The light, fresh colours of these background carpet stripes are unmistakably his own.

'Tropical Flowers' (below). An exuberant riot of fun from Kaffe Fassett.

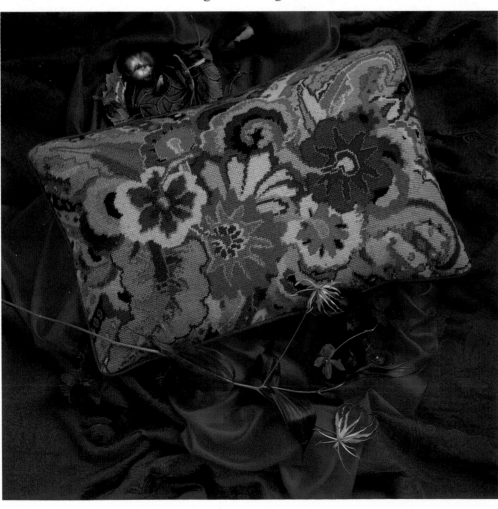

hurricanes of recent years, but agriculture is now in retreat and quite substantial growth in woodlands is widely predicted. Nature has a habit of surprising us. In the great storm of 1987 in England it was reported that 15 million trees had been lost. In fact, most uprooted trees stayed alive and flourished horizontally and some now argue that clearing up and replanting have done more damage than the storm. England has some of the finest trees in the world and a great variety of them. Leaves feature in a number of our tapestries so it is quite surprising that 'Night Tree' is the only one which actually features a tree.

Now we come to 'Tropical Flowers', shown below. Kaffe is really cooking up a storm here, with poly-chromatic fireworks in shimmering primaries exploding and rioting all over the canvas. As one of our customers said to me, 'What do you feed him on, and why can't I have any?' This has to be the apogee of his journey of discovery into the realms of electric colour. But even when working with such vivid combinations a freshness and subtlety is present that is typical of all his work. The fuchsias, scarlets, emeralds and bright yellows may be the colours that hit you first but look closer. They are blended into a harmonious whole with the help of a far paler mauve, offwhite, corn-flower and sand. The shading of the blues and greens then adds a three-dimensional touch. It is a riot, an exuberant and wonderfully joyous riot, and is a splen-did example of how really strong colour can be used with taste. If you are wondering why this design is in-cluded in a chapter on textiles it is because the original colourway, a very different Matisse-like colourway which appeared as a chairseat in *Glorious Needlepoint*, was based on a combination of Chinese pot decora-tions and old embroideries. The outsize leaves and swirling pattern in the original are reminiscent of Jacobean embroidery but an Eastern flavour, like a Tibetan painting, is added with the effects of clouds and the more fluid outlines of some of the shapes. The design is a novel mixture of influences which is largely obscured by the drama of this particular colourway.

The last in this collection of tapestries is the 'Rib-bon and Rose', shown on page 87, which is an arche-typal Kaffe Fassett design combining many of his favourite themes: the stripes and squares of Eastern rugs, roses, waving ribbons and lively fresh colour. It is a large and comfortable cushion measuring 530×530mm (21in) square and is stitched on 7-mesh canvas with the wool used double. As it is on 7-mesh canvas, it could also be used as a chairseat and it will wear well. Floral emblems laid over patterns is a familiar Kaffe Fassett touch and geometrics and flowers often combine surprisingly well. Kaffe gives a tremendous depth of colour to these roses. The subject is one of his favourites and he has created several rose designs over the years. 'Esfahan Rose' was one of our earliest and most successful kits and the roses in the 'Flower Trellis Carpet' are, I think, the most striking

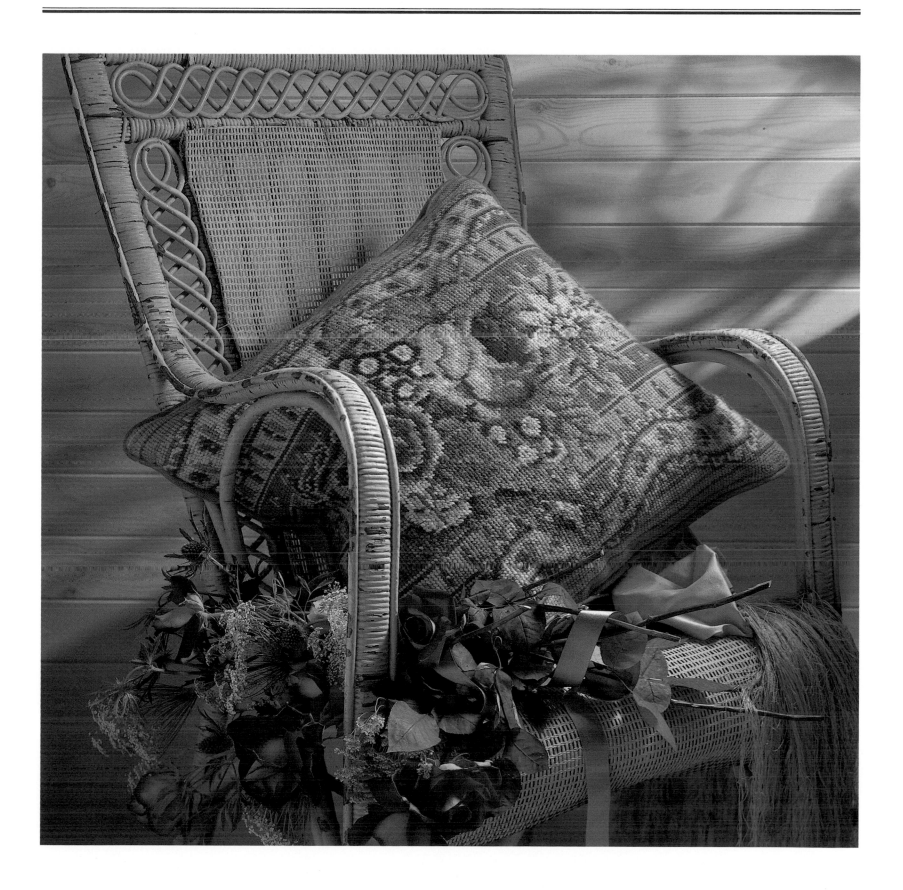

A green glass Huqqa vase (above) with gilded poppies from the Oriental Antiquities Collection of the British Museum. This beautiful object was made in Mughal India around 1700. Here is a typical Indian floral emblem which appears again and again in the painted borders of Mughal manuscripts, on carpets and shawls, cotton chintzes or carvings in ivory and stone. These Mughal studies of flowering plants we now know were influenced by early seventeenth-century European etched and engraved herbals, but there is no mistaking their uniquely Indian style. Kaffe Fassett has taken this stylistic tradition of arranging single flowers to form patterns in 'Carpet Garden' seen on page 80. These spherical or bell-shaped Huqqa vases were decorated by a manuscript painter rather than by the glassblower.

part of that design. Another of Kaffe's very early kit designs was 'Baroda Stripe' with slanting carpet stripes in pastel shades. The background stripes of 'Ribbon and Rose' are very similar and it is interesting seeing these two themes combined together in one tapestry ten years later. The outer edges are a series of much thinner stripes and the clearest influence here is Kaffe's own knitting. Some of his earliest knitwear patterns were simple stripes and they are also present in a number of the collections which he designed for Bill Gibb.

For nearly ten years alongside our tapestry kits we have produced a smaller range of knitting kits. Our four main knitwear designers have been Kaffe Fassett, Susan Duckworth, Sasha Kagan and the team of Jamie and Jessi Seaton. With the possible exception of Sasha Kagan, all their work is heavily influenced by motifs and patterns found in textiles, and these knitting patterns have in turn had an influence on our tapestries. Susan Duckworth, for example, has adapted ideas from her knitting for use in tapestries she has designed for us, and the Seatons' knitwear often reflects patterns and colours from textiles found around the world. This has created a stylistic link between our knitting and tapestry and the link is at its strongest with Kaffe Fassett who is as well-known for his knitting as his needlework. Kaffe's knitwear is famous for its blends and shifts of colour and anyone who saw his television series will have watched with fascination as he gradually built these textures. He was the first to mix different weights of yarn and the richness both of colour and texture that this produces has become his hallmark.

Kaffe had wanted us to produce knitting kits with him for a number of years and my brother Richard and I had always refused as in the early days we were being kept busy by tapestries, ceramics, jewellery and silver. But in 1982 we began to concentrate solely on tapestry and at the same time Kaffe had found a company in Yorkshire that was prepared to dye his own yarns. I remember him ringing to say that he had found 'two young guys up in Yorkshire who are going to dye my yarns. Now you *have* to do knitting kits!'

The two 'guys' were Stephen Sheard and Simon Cockin of the Rowan Weavers – they produced weaving kits for the craft market in those days – and this was the start of Rowan Yarns which, over the next ten years, was to become one of the best-known names for quality knitting yarn in England. We all met to discuss the production of the kits and I approached Susan Duckworth and Sasha Kagan to produce designs for us and to introduce them to Kaffe's new knitting yarns. It was a very exciting time as nobody else was producing knitting kits by top designers and nobody was producing yarns like Rowan. Designer knitwear skyrocketed for the next five years as it luckily co-incided with a fashion for handknitting and the hand-knitted look. Then, almost as abruptly, it went into decline and the reasons for this are threefold. The busy, handknit look has been out of fashion lately; the kits seem relatively expensive with the luxurious yarns we now use; and they are difficult to knit. The complexity is inescapable. The richness that these designers like to get into their knitwear can only be achieved by complex patterns and we have never wanted to water down their style. To remain different from the very competent machine-made imitations now available, our patterns must be rich in texture and design, but only a limited number of knitters can tackle these patterns and the end result must be very special to justify the cost. Oddly enough, the exact opposite applies to our tapestries. They employ only one simple stitch and are all followed from a pre-printed colour canvas. Many of our knitters now do our tapestry kits as a light break from their labours! We have no intention of altering the style of our knitwear as its difference is its strength but it can only ever be for a limited market which is sad but, I am afraid, inevitable. Our tapestries, however, can be tackled by anyone and are often stitched in front of the television or on trains. They are good for taking on holiday, can be packed and unpacked without fuss, and stitched at any pace. The majority of our customers will take a year or so to stitch a kit, doing different pieces when they feel in the mood. There is no particular hurry in stitching a tapestry, whereas a knitting

kit is for wearing so becomes a project requiring completion. Once again, it was Kaffe who advised us to stick to simple stitches for the tapestries and to concentrate on the pattern and colours of the designs. I am very glad that we did, although some stitchers might see it as a limitation and wish to add surface texture with a variety of stitches.

With the other three tapestries in this chapter the focus moves from East to West. Looking at Candace Bahouth's 'Bruges' you will detect an immediate association with tapestries of the Middle Ages. It was directly inspired by the millefleurs tapestry series, the *Lady and the Unicorn*, in the Cluny Museum in Paris.

(continued on page 92)

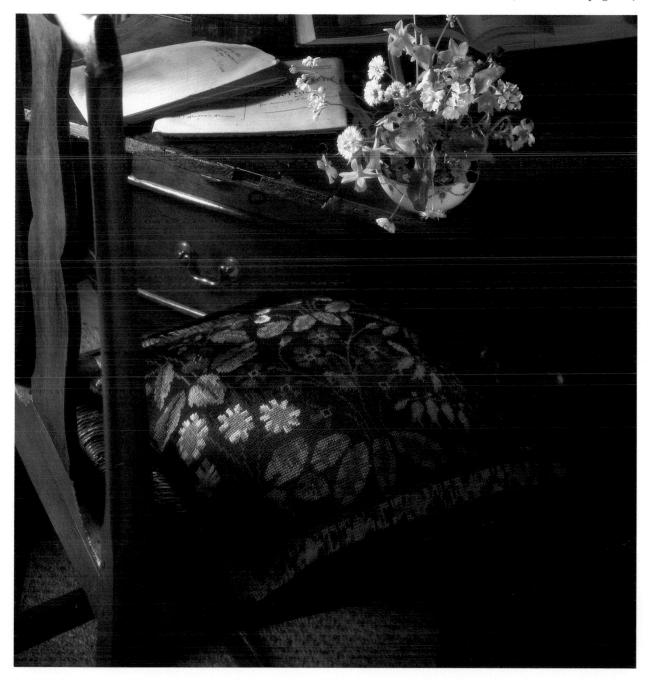

'Bruges' by Candace Bahouth (left). Taking the millefleurs backdrop of the medieval tapestries in the Cluny Museum in Paris as her starting point Candace Bahouth substituted English flowers, that would have grown wild in the Middle Ages, for the French originals. Cheddar Pink, Sticky Catchfly, Rock Cinquefoil, Saxifrage, Diapensia, Alpine Snowthistle, Wild Gladiolus, Snowden Lily, Fen Violet, Teesdale Violet, Alpine Gentian and Red Helleborine were all considered, with six finally selected. Set against a deep viridian background she skilfully manages to evoke the colours of the time, so that this cushion really has the feel of a medieval woven textile. These dark background colours can be seen in the illustration on page 95. In the Lady and the Unicorn *tapestry series at the Cluny Museum, the background to the millefleurs fields is a faded strawberry pink and Candace Bahouth uses that colour for 'Anjou,' her tapestry featured on page 111.*

BRUGES
by Candace Bahouth

Looking at Candace Bahouth's 'Bruges' you will detect an immediate association with tapestries of the Middle Ages. It was directly inspired by the Millefleurs tapestry series, the Lady and the Unicorn, *in the Cluny Museum in Paris. Candace is a weaver by profession, producing large-scale hangings to commission. Her artistic interests have taken her into many other fields from garden furniture to painting and I am delighted that her current passion is needlework design.*

MATERIALS
Tapestry wool (see Colourways). The amounts given are for tapestry wool worked in basketweave or continental tent stitch. If the design is worked in half-cross stitch, 30 per cent less wool is required. Double-thread or interlock canvas is suitable for all three types of tent stitch, but if basketweave or continental tent is used an ordinary mono canvas may be substituted. Three strands of Persian wool or four strands of crewel can be substituted for the single strand of tapestry wool used here. (To calculate amounts for crewel or Persian wool see page 113.)
10-mesh double or mono interlock canvas 50cm (20in) square
Size 18 tapestry needle
50cm (20in) furnishing fabric for backing
1.8m (2yd) narrow piping cord
Cushion pad (pillow form) 41cm (16in) square
30cm (12in) zip fastener (optional)
Scroll or stretcher frame (optional)
Tools and materials for preparing canvas (see page 114) and for blocking (page 115)

The finished cushion measures 41cm (16in) square and is worked on 10-mesh canvas.

WORKING THE EMBROIDERY
Prepare the canvas and mount it on the embroidery frame, if used (see pages 114 and 115).

Following the chart on the right and using a single strand of tapestry wool, work the design in basketweave or continental tent stitch, or in half-cross stitch.

BLOCKING AND MAKING UP
Block the completed work (see page 115) and allow it to dry thoroughly. Trim the canvas edges, leaving margins of 2cm (¾in).

From the backing fabric cut a piece 45cm (17½in) square. Or, if inserting a zip, cut two pieces as specified on page 116.

From the remaining fabric, cut and join bias strips to cover the piping cord (see page 117). Make up the piping.

If using a zip, insert it in the back cover (see page 116).

Attach the piping to the back cover as described on page 117.

Join the front and back covers as described on page 117, and insert the cushion pad.

COLOURWAYS AND YARN AMOUNTS
The cushion cover pictured was worked in Appleton tapestry wool. DMC tapestry wool colours are given as an alternative; you should note, however, that colours in an alternative brand of yarn will only provide approximate equivalents.

- 103m (112yd) of Appleton 159 (or DMC 7429)
- 60m (65yd) of Appleton 156 (or DMC 7701)
- 15m (16yd) of Appleton 527 (or DMC 7596)
- 42m (45yd) of Appleton 293 (or DMC 7394)
- 17m (18yd) of Appleton 567 (or DMC 7306)
- 17m (18yd) of Appleton 565 (or DMC 7304)
- 10m (11yd) of Appleton 564 (or DMC 7802)
- 14m (15yd) of Appleton 563 (or DMC 7302)
- 12m (13yd) of Appleton 225 (or DMC 7758)
- 10m (11yd) of Appleton 206 (or DMC 7356)
- 29m (31yd) of Appleton 951 (or DMC 7523)
- 17m (18yd) of Appleton 695 (or DMC 7474)
- 18m (19yd) of Appleton 694 (or DMC 7504)
- 12m (13yd) of Appleton 882 (or DMC 7491)

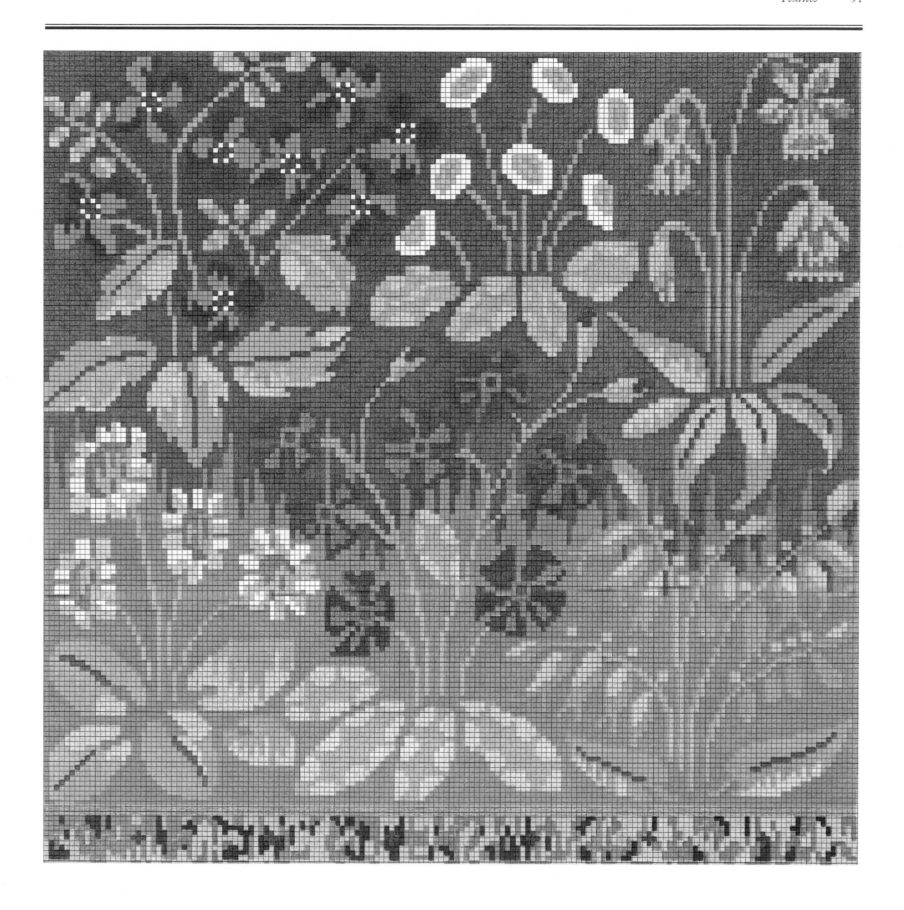

If you ever get the opportunity to visit this museum take it. You will probably only spend about an hour there but you will see some of the most outstanding examples of medieval painting, sculpture, tapestry and, above all, wood carving. It is a period in Western art which I have always found very moving. The skills of the craftsmen and their technology was far cruder than anything you will find a hundred years later. As we all know, the Renaissance accelerated with a huge leap the world of the visual arts – perspective, range of subject matter and technical ability – but the earlier works of these medieval craftsmen had something which has been lost for ever from Western art. It was a sense of awe of the divine. It can be felt equally strongly in the music of Byrd or Tallis and it fills the artefacts of the time with a conviction that at times can be quite startling. In a way it is similar to the powerful peasant vigour of the tribal carpets I mentioned earlier. The works are slightly naïve and technically a little crude, but the souls of the craftsmen shine through.

In the Middle Ages woven tapestries in the West served the same function as wallpapers and fabrics do nowadays. They were for filling up the walls, decorating and adding warmth to a building. We know that merchants of the time not only ordered tapestries to be woven for a particular place but kept stocks of different sizes: large ones for the main halls, medium-sized for chambers and smaller ones for door curtains. Immense time and effort went into their design because of their expense and importance. As Francis Salet writes, 'Tapestries, together with goldsmiths' work were, above all else, a means of asserting rank and wealth, and consequently a means of making the Prince's power felt and seen.' If you consider the thought and time that goes into designing status symbols of comparable importance today – say cars or expensive clothes – it is not surprising that medieval tapestries were such detailed, massive and impressive works. The Burrell Collection in Glasgow, Scotland, and the Cloisters in New York have as good examples as the Cluny Museum in Paris and a visit to any will open your eyes to the beauty of these woven fabrics.

The themes for these tapestries tended to run along lines: hunting parties, battles, landscape vistas, field upon field of stylised flowers and animals in abundance. In 'Bruges' Candace Bahouth bases her design on these background fields of flowers but has substituted English flowers which would have grown wild in the Middle Ages for those found in the original French tapestry. It is unusual in having a border only at the bottom and the colours of the fleurs-de-lis blend with the soft, slightly faded shades of the flowers to capture the feel of the now bleached and well-weathered original. Not that the original colours would have been faded at all. We know that in Tudor times interiors were brilliantly coloured. A writer in 1558 talks about the profusion of tapestry and printed cloths used in English houses which came fresh from the loom or brush in vivid colours. These medieval tapestries would no doubt have been strongly coloured to start with as well. By Tudor times the combination of these fabrics with the carved ornament and painted and gilded plasterwork must have been positively gaudy.

In the seventeenth and eighteenth centuries both tapestries and the less durable silks and velvets were used as wallcoverings. Most tapestries were manufactured abroad, either in Brussels or at the Gobelins factory in France. Occasionally they were ordered to an exact size to fill a particular wallspace but usually they were bought as groups, in lots of three or five, and that is why they were often carried round the corners of rooms when hung. They were not tailormade for their surroundings and simply didn't fit properly. The variety of textiles used as wallhangings was fabulous. The inventory for the contents of Ham House, Surrey, in 1679 reveals the blue drawing room hung with panelled silk, another room hung with mohair bordered with clouded satin and the bedchamber with panels of yellow damask, each one framed with blue mohair. Damasks and large patterned velvets from Italy were popular throughout the eighteenth century. In a contemporary description of Houghton Hall, Norfolk, in 1760 the drawing room was hung with Coffoy, the salon with crimson velvet

'Tapestry Fragment' by Margaret Murton (left). *This cushion has been photographed perfectly by Rosemary Weller to illustrate its character. It has the rich faded flavour of damask, brocade and embroidered textiles.*

and the bedchambers with velvet, tapestry or needle-work hangings. A letter in 1741 from Sir Thomas Robinson discusses velvets and damasks from Genoa: 'This one article is the price of a good house, for in one drawing room they are to the value of £3,000.' Imagine how far £3,000 went in 1741. It makes Donald Trump's or Imelda Marcos's fabled redecorations look almost parsimonious!

Margaret Murton's 'Tapestry Fragment', shown above, is in the tradition of these later tapestries and printed fabrics. It was nearly included in the first chapter on decorative and ornamental design, along with her group of other similar tapestries, but I think it is even more appropriate to include it here as it illustrates the influence of textiles from all periods on the designs for our kits. As its name implies, it seeks to replicate a section of older tapestry that has been cut to make a cushion. The colours remind me of those found in Mortlake tapestries of the seventeenth and eighteenth centuries, although they would have used less pale yellow and pink. It was the first tapestry Margaret designed and the way she has captured the faded shades with soft and expert blending of colour is astonishing for the first attempt at working in wool. It remains one of her best designs and, like all of her classically inspired cushions, would blend anywhere.

'Flowing Flower' by Candace Bahouth (right). *This was one of Candace Bahouth's first designs for us. She is a weaver by profession and I think this early work of hers has a textural quality associated with woven fabrics.*

A panel from the La Vie Seigneuriale *series of tapestries* (opposite page) *in the Cluny Museum, Paris. The six tapestries evoking the life of a lord and lady around the year 1500 is undoubtedly one of the finest works of art that has come down to us from the late Middle Ages. A quote from Kenneth Clark, writing in* Landscape into Art *puts it perfectly:*
'In these tapestries the dark woods of the middle ages are to fill, with beautiful patterns of leaves and branches, the whole upper portion of each design, while the lower half is as richly sprinkled with flowers as the meadows of Boccaccio. . . From a hundred examples that which comes first to mind is the series of the Lady with Unicorn *in the Cluny Museum, where the subject itself symbolises the triumph of delicacy over the wild impulses of nature.'*
The fields of stylised flowers form the basis of Candace Bahouth's 'Bruges' seen on page 89. The figures in this panel, The Bath, *appear to float on a luxuriant sea of flowering plants without touching the ground.*

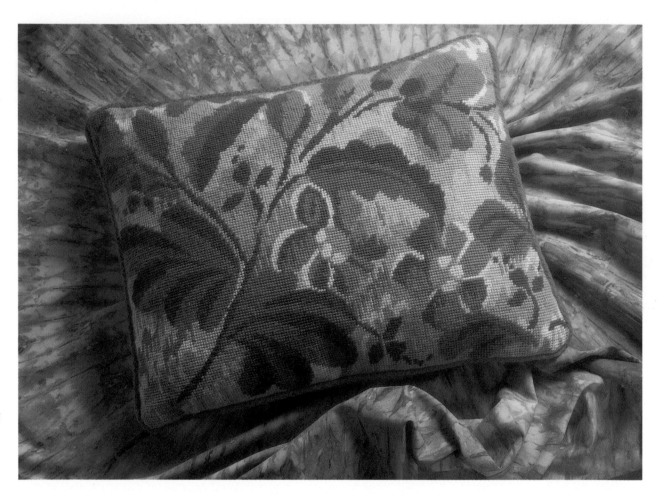

The last design, but by no means the least, is Candace Bahouth's 'Flowing Flower' which is a maverick and most original. The use of greys is surprising and effective and the single curling flower on the bargello-effect background has a good boldness to it. In a completely different way from 'Tapestry Fragment' it is also like a section of woven fabric which has been cut up to make a cushion. It certainly reminds me of textile patterning but the various influences are so discreet it is impossible to analyse them. That doesn't matter at all as it is an excellent design in itself and its sophisticated choice of colour marks it out. It is distinct from much of Candace's other work but there is a link, however, between this design and her other tapestries, in particular 'Anjou' on page 111, in the way she has stitched the background. The fuzzy shifts of colour used in these backgrounds are inspired by similar background effects found in both woven and printed textiles.

All needleworkers have a love of textiles of one sort or another. It is this fondness for textiles generally as much as the art of stitching which attracts many to needlework in the first place. Natural human curiosity ensures that no needleworker could fail to be intrigued by the achievements of the past in their particular discipline. For those who enjoy designing their own work another look at the textiles that are displayed in museums or illustrated in the many beautifully presented books on the subject will prove worthwhile. Textiles from all over the world, not just Asia and Western Europe, have inspired the designers in this book. We should have no qualms in plundering other cultures for ideas. In the process, we can all learn a great deal and broaden our horizons.

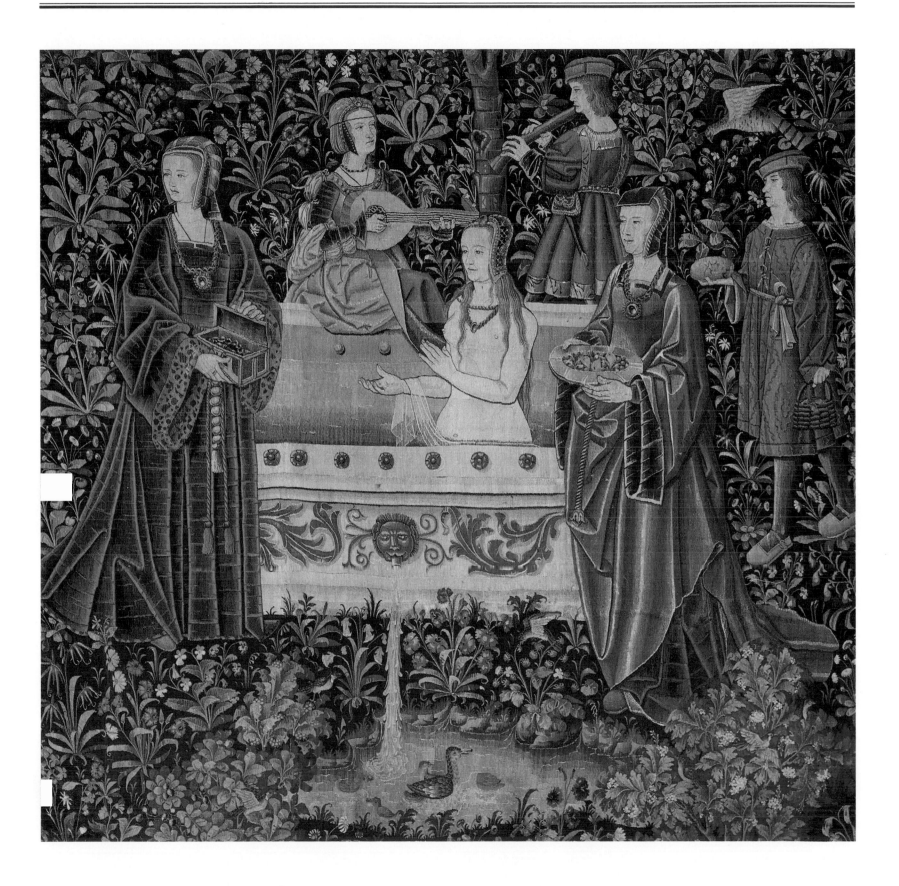

SHADINGS

The subtleties of colour shading have been referred to throughout this book and if Ehrman's tapestries were collectively known for one thing it would probably be for this. Most of our designers grade and blend their colours to evoke a sense of texture in the tapestries. Colours merge, they don't collide and, although not invariably the case, it is true of nearly all the designs in this book. This is due to the designers' fundamental approach to their task: they are not painting pictures which are then transposed into needlework but are setting out to create embroidered textiles for walls, cushions, chairs or floors, and the use of colour is appropriate to the end product. This is even true, although to a lesser extent, of the canvases that are specifically designed as pictures. Patterned textiles require a subtle touch with colour and hence the emphasis on shading throughout our range. It is a good theme to end with as it highlights the common denominator running through the work of such a disparate group of designers – a determination to paint with wool.

Anyone working with wool is for ever both excited and frustrated by the range of colours available to them. Since wool shades cannot be mixed up like paints the range is necessarily limited and the designers we work with will use a particular brand of tapestry wool to achieve a particular look: Appleton's for soft, faded tones, Paterna for sharper, livelier colours and Anchor for a generally representative selection. There is a letter written by William Morris in March 1876 to Aglaia Coronio which perfectly captures this longing for a personal palette that all needleworkers understand. William Morris was frustrated with the shades of wool available so decided he would try to dye up his own (in the same way as Kaffe Fassett did with Rowan's knitting wools, a hundred years later). In the letter Morris writes:

> I am working in Mr Wardle's dye-house in Sabots and blouse pretty much all day long: I am dyeing yellows and reds: the yellows are very easy to get, and so are a lot of shades of salmon and flesh-colour and buff and orange; my chief difficulty is in getting a deep blood red, but I hope to succeed before I come away: I have not got the proper indigo vat for wool, but I can dye blues in the cotton vat and get lovely greens with that and the bright yellow that weld gives.
>
> As to going on with the enterprise of the wool-dyeing, I am determined to do so in some way or other; because so much of my work depends on the solving of the difficulty, that no amount of money could compensate me for the disappointment if I had to give it up.

And in the next year, writing to Thomas Wardle, came a cry from the heart:

> I suspect you scarcely understand what a difficult matter it is to translate a painter's design into material: I have been at it for sixteen years now, and have never quite succeeded.

I am sure we can all sympathise with the way he felt.

William Morris was a textile designer. He was not an embroiderer or tapestry weaver and the actual manufacture of his works was nearly always carried out by others to whom he delegated. This partially explains his continual frustrations in achieving the colour balances he had in his mind. The majority of our designers work in the same way, translating paintings to graph paper or designing paintings in colour sections for application on to canvas. But many don't, preferring to stitch the design as they go along, altering and adapting as it develops. This is how Kaffe Fassett works and it enables him to add touches of colour to create soft blends of shading or shadows. This pointillist approach to painting with wool is revolutionary. Such a degree of subtlety could not be achieved by conscious design. It is the way a painter works, adding unexpected touches here and there to balance the whole as it progresses. When people look at the colour blends of his apples or cabbages they often ask 'How did he "design" them?'. The answer is he didn't, he stitched them. I know of no other textile designer who has worked in this way and the scope for innovation is limitless. The task of translating these stitched designs, with their tiny dots of colour, to printed canvas is a monumental exercise in precision and care. It is carried out for us by Gillian Meakin at William Briggs and Jean Stanley at Readicut who

have both developed a rapport with Kaffe's work which goes beyond the technical. They can almost sense what he intended for a particular section where the stitching may not be clear and their contributions to the production of these highly detailed canvases should not be overlooked. The printing in turn has to be exact and the technical improvements in the printing of these tapestry canvases which has taken place over the last five or six years has gone hand in hand with Kaffe's revolution in design.

The 'Apple and Cabbage Carpet' is a splendid monument to this technique of stitching and a good example of the irregular use of pattern repeat which we talked about in chapter 3. It is a massive carpet, measuring roughly 150×215cm (5ft×7ft), and is worked in seventeen separate sections which are then sewn together. Like all of Kaffe's other rugs and carpets, it is worked in half-cross stitch with the yarn doubled-up on 7-mesh canvas. Some cabbages and apples in the squares are repeated, the majority are not, and the borders are mirror images in reverse. This is a clever use of design and is typical of the way he treats repeat patterns – the overall picture appears to be a structural geometric repeat but at closer inspection it is far more complicated. This gives the design its richness and vigour. But, of course, the real richness is once again in the use of colour and his depiction of both the apples and cabbages is superb. They jump out of the tapestry at you. The two cushions have a wider border but are otherwise based on sections taken from the carpet. This took many months to complete, with different sections being worked by different members of Kaffe's group of stitchers, and the composition of the whole was held

'Apple and Cabbage Carpet' by Kaffe Fassett (below). *The kit for this massive project comes as one, but the two apple cushions 'Miller's Seedlings' and 'Discovery' are individual cushion kits and can be bought separately. We also took the central panel of yellow apples and made that available as a kit last year. To stitch this carpet is a serious undertaking, but we have sold nearly a hundred since it was first launched two years ago, which is far more than we originally expected.*

March (right) *from Furber's series of* Twelve Months of Flowers and Fruits *at the Victoria and Albert Museum, London. Robert Furber owned a large nursery in Kensington in the early eighteenth century where he grew trees, shrubs and herbaceous plants. He engaged a Flemish flower painter Pieter Casteels to paint a vase of flowers in the Dutch manner for each month of the year. These were reproduced in Furber's* Twelve Months of Flowers *in 1730;* Twelve Months of Fruit, *from which this plate is taken, followed two years later.*

These sumptuous catalogues advertised nearly 800 varieties of flowers and fruits obtainable from his nursery. The success of these catalogues led to an inferior reproduction of the plates in The Flower Garden Display *in 1732 aimed at a wider audience. Its title page recommended it as 'very useful, not only for the curious in Gardening, but the prints likewise for Painters, Carvers, Japaners, etc. also for the ladies, as patterns for working and painting in watercolours or furniture for the closet.' They certainly do make magnificent source material for artists of all persuasions, so why not for needleworkers too?*

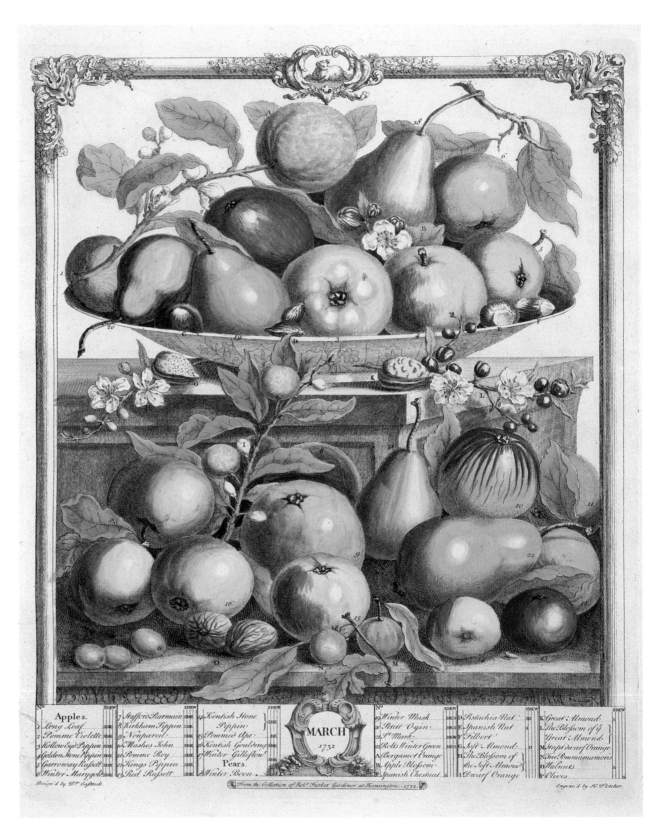

in Kaffe's head with minimal planning or graphs. He has an astonishing ability for holding complex design structures in his head and can work on detailed colour gradations without losing sight of the final scale. I once heard him designing a colourway for a knitting kit on the telephone! He was about to catch a plane so gave instructions, row by row, to one of his knitters, specifying each yarn and colour-change without looking at the pattern or any shade cards.

The 'Melons' on this page are in the same tradition and could themselves be worked up into carpet squares to make a very dramatic rug. The colour highlights of fruits have become one of Kaffe's specialities, and so are the shadows he gets into his leaves. This fascination with the soft, round shapes of fruits goes back a long way and he has now designed plums, pears, cherries, apples and melons as kits and next year will be adding grapes and strawberries. Fruits are better vehicles than vegetables for catching these colour highlights and all these tapestries of his capture those lustrous, slightly shiny, surfaces common to most fruits. 'Writers on art, from classical times onwards, have always maintained that colour is the sensuous and emotional element in painting,' says Kenneth Clark in *Landscape into Art*. What is true for fine art is equally true for the decorative arts, and as we look at the last design by Kaffe Fassett in this book we should leave his work on that note. Kaffe's sensuous and emotional use of colour is probably at its strongest in his fruits, vegetables and flowers. They are the works of a painter, a painter with wool, who achieves his effects by the assiduous detail of colour shading and this, more than anything else, is his unique contribution to the field of needlework.

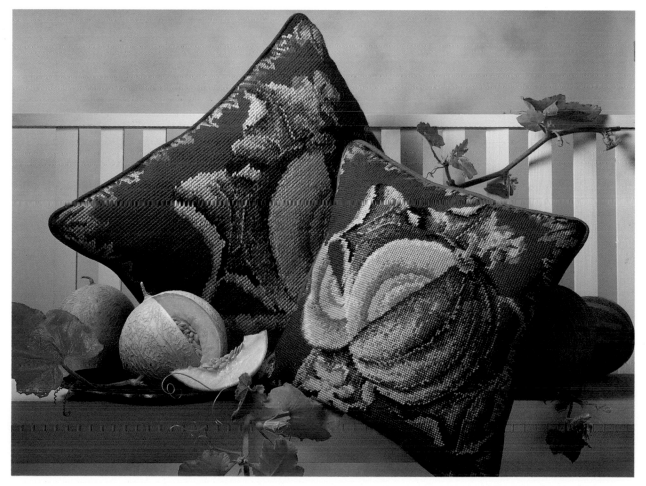

'Melons' by Kaffe Fassett (left). The two sizes are stitched on a different mesh of canvas. The larger is on seven to the inch and stitched with the wool used double, the smaller is on ten to the inch. Kaffe has always been intrigued by melons and at his exhibition at the Victoria and Albert Museum a magnificent tapestry of his depicting a melon and leaves was shown.

John Evelyn described the melon as 'The noblest production of the garden' as they were so difficult to grow. They still are, requiring heat, hand pollination and constant protection from pests and diseases. Their introduction to Europe was via Rome where they arrived as one of the spoils of war against Mithridates. One of the most popular varieties is still called 'Canteloup' after a location near Rome.

MELONS
by Kaffe Fassett

Kaffe Fassett stitches the design as he goes along and it enables him to add touches of colour to create soft blends of shading or shadows. This pointillist approach to painting with wool is revolutionary. Such a degree of subtlety could not be achieved by conscious design. It is the way a painter works, adding unexpected touches here and there to balance the whole as it progresses. I know of no other textile designer who has worked in this way and the scope for innovation is limitless.

MATERIALS
Tapestry wool (see Colourways). The amounts given are for tapestry wool worked in basketweave or continental tent stitch. If the design is worked in half-cross stitch, 30 per cent less wool is required. Double-thread or interlock canvas is suitable for all three types of tent stitch, but if basketweave or continental tent is used an ordinary mono canvas may be substituted. Three strands of Persian wool or four strands of crewel can be substituted for the single strand of tapestry wool used here. (To calculate amounts for crewel or Persian wool see page 113.)
10-mesh double or mono interlock canvas 45cm (18in) square
Size 18 tapestry needle
45cm (18in) furnishing fabric for backing
1.6m (2yd) narrow piping cord
Cushion pad (pillow form) 36cm (14in) square
25cm (10in) zip fastener (optional)
Scroll or stretcher frame (optional)
Tools and materials for preparing canvas (see page 114) and for blocking (page 115)

The finished cushion measures 36cm (14in) square and is worked on 10-mesh canvas.

WORKING THE EMBROIDERY
Prepare the canvas and mount it on the embroidery frame, if used (see pages 114 and 115).

Following the chart on the right and using a single strand of tapestry wool, work the design in basketweave or continental tent stitch, or in half-cross stitch.

BLOCKING AND MAKING UP
Block the completed work (see page 115) and allow it to dry thoroughly. Trim the canvas edges, leaving margins of 2cm (¾in).

From the backing fabric cut a piece 40cm (15½in) square. Or, if inserting a zip, cut two pieces as specified on page 116.

From the remaining fabric, cut and join bias strips to cover the piping cord (see page 117). Make up the piping.

If using a zip, insert it in the back cover (see page 116).

Attach the piping to the back cover as described on page 117.

Join the front and back covers as described on page 117, and insert the cushion pad.

COLOURWAYS AND YARN AMOUNTS
The cushion cover pictured was worked in Anchor tapestry wool. DMC tapestry wool colours are given as an alternative; you should note, however, that colours in an alternative brand of yarn will only provide approximate equivalents.

■	8m	(9yd)	of Anchor	0739	(or DMC 7429)
■	40m	(44yd)	of Anchor	3023	(or DMC 7540)
■	34m	(37yd)	of Anchor	0216	(or DMC 7370)
■	9m	(10yd)	of Anchor	0265	(or DMC 7549)
■	18m	(20yd)	of Anchor	0505	(or DMC 7323)
■	14m	(16yd)	of Anchor	0837	(or DMC 7322)
■	18m	(20yd)	of Anchor	3149	(or DMC 7369)
■	11m	(12yd)	of Anchor	3072	(or DMC 7115)
■	48m	(53yd)	of Anchor	0701	(or DMC 7184)
■	11m	(12yd)	of Anchor	010	(or DMC 7104)
■	15m	(17yd)	of Anchor	3186	(or DMC 7919)
■	16m	(18yd)	of Anchor	0196	(or DMC 7173)
■	8m	(9yd)	of Anchor	0727	(or DMC 7726)
■	9m	(10yd)	of Anchor	3276	(or DMC 7501)

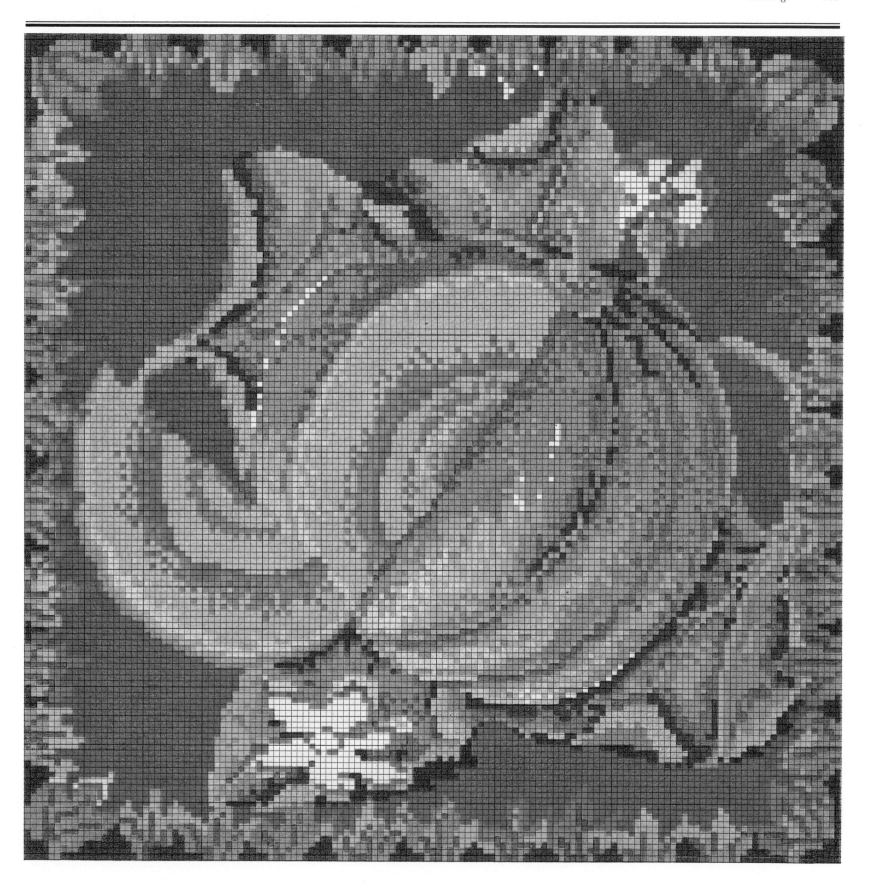

Sarah Windrum lives in Wales surrounded by breathtaking views of some of the most beautiful countryside you will find anywhere in the British Isles. A few years ago she designed a kit for us featuring sheep in a landscape setting. The sheep grazed in fields in the early morning with soft sunlight slanting through the mist and the Welsh hills in the background beyond. It was an exercise in soft colouring and relied on very precise shifts of tone to capture the detail in the picture. The design had a wide paisley patterned border of swirling leaves which echoed the restrained colours of the picture and 'Forest Floor' is based on this border. The sheep picture proved so popular that I thought it would be interesting to take the border and redesign it as an all-over pattern and Sarah has managed to do this with great skill, adding a thin geometric outer border to hold it all together. The dots of green, yellow and blue are another example of the pointillist technique for shading and, combined with the very soft and subtle tones of the leaves, creates a marvellous mélange of misty colour. Sarah Windrum has designed tapestries for many years, although we only made contact relatively recently. She was for a short time at the Weatherall Workshop in the late 1970s and now works with her partner Susie Martin, whose paintings often provide Sarah with subject matter for tapestries. Like so many other designers featured here, the link between needlework and painting is strong, and the parallel link between painting and colour shading with wool is self-evident. I like the sense of movement in the abstract patterns of the leaves and it is a welcome change to have a cushion which is hardly representational at all. Geometric and abstract patterns often look harsh in needlework. This is because blocks of pure colour abut on to each other and, even on a small scale, this gives the design a hard edge. By merging complexions, blurring edges and sprinkling dots of soft colour, Sarah Windrum shows how to avoid this pitfall.

'Maple Leaves' is also the work of a painter – the colours in the leaves almost feel like paint. Margaret Murton has not, however, used detailed dots of varie-gated colour stitching and, surprisingly, the background is a single, flat colour. The leaves dominate, taking up most of the surface area of the design, so the plain background is absolutely correct for the context and emphasises the shapes and colours of the leaves. These are quite beautiful and, although colour is used in generous strokes, it is combined in such a rich and sumptuous way that it blends like a painting. Here are blocks of colour to stitch and the shading is achieved quite simply by the restricted group of colours – red, mauves, browns and yellows juxtaposed in different combinations. To shade your needlework designs, you do not have to use a lot of colours in small quantities, although that is one way of doing it. A restricted range of sympathetic colours, used with variety, can be equally successful. This cushion could have gone just as well in the chapter on pictorial design but its use of colour is as memorable as the clarity of its draughtsmanship.

'Forest Floor' by Sarah Windrum (opposite page). I would love to see this design form the basis of a rug. One day perhaps, when Sarah has time, we can persuade her to do so. Its soft blend of colours and the gentle swirl of its pattern would look good on a larger scale.

'Maple Leaves' by Margaret Murton (below). The useful thing about this large, comfortable cushion is that it looks fine from any angle. In fact we photographed it upside down in last year's catalogue, and no one would have known if an understandably offended Margaret Murton had not pointed this out to me!

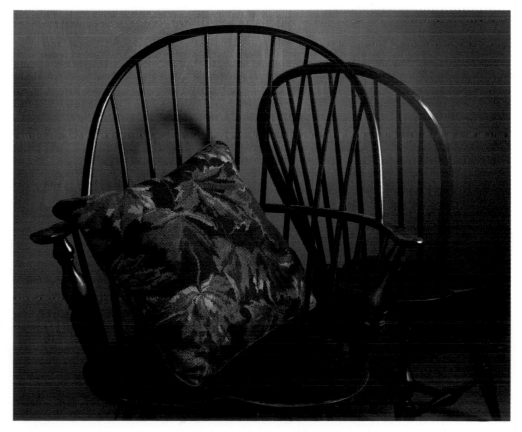

MAPLE LEAF
by Margaret Murton

'Maple Leaves' is the work of a painter – the colours in the leaves almost feel like paint. The leaves dominate, taking up most of the surface area of the design, so the plain background is absolutely correct for the context and emphasises the shapes and colours of the leaves. These are quite beautiful and, although colour is used in generous strokes, it is combined in such a rich and sumptuous way that it blends like a painting.

MATERIALS

Tapestry wool (see Colourways). The amounts given are for tapestry wool worked in basketweave or continental tent stitch. If the design is worked in half-cross stitch, 30 per cent less wool is required. Double-thread or interlock canvas is suitable for all three types of tent stitch, but if basketweave or continental tent is used an ordinary mono canvas may be substituted. Three strands of Persian wool or four strands of crewel can be substituted for the single strand of tapestry wool used for this design. (To calculate amounts for crewel or Persian wool see page 113.)

10-mesh double or mono interlock canvas 55cm (22in) square
Size 18 tapestry needle
55cm (22in) furnishing fabric for backing
2m (2¼yd) narrow piping cord
Cushion pad (pillow form) 46cm (18in) square
35cm (14in) zip fastener (optional)
Scroll or stretcher frame (optional)
Tools and materials for preparing canvas (see page 114) and for blocking (page 115)

The finished cushion measures 46cm (18in) square and is worked on 10-mesh canvas.

WORKING THE EMBROIDERY

Prepare the canvas and mount it on the embroidery frame, if used (see pages 114 and 115).

Following the chart on the right and using a single strand of tapestry wool, work the design in basketweave or continental tent stitch, or in half-cross stitch.

BLOCKING AND MAKING UP

Block the completed work (see page 115) and allow it to dry thoroughly. Trim the canvas edges, leaving margins of 2cm (¾in).

From the backing fabric cut a piece 50cm (19½in) square. Or, if inserting a zip, cut two pieces as specified on page 116.

From the remaining fabric, cut and join bias strips to cover the piping cord (see page 117). Make up the piping.

If using a zip, insert it in the back cover (see page 116).

Attach the piping to the back cover as described on page 117.

Join the front and back covers as described on page 117, and insert the cushion pad.

COLOURWAYS AND YARN AMOUNTS

The cushion cover pictured was worked in Appleton tapestry wool. DMC tapestry wool colours are given as an alternative; you should note, however, that colours in an alternative brand of yarn will only provide approximate equivalents.

- 87m (95yd) of Appleton 583 (or DMC 7469)
- 21m (22yd) of Appleton 186 (or DMC 7514)
- 46m (50yd) of Appleton 125 (or DMC 7632)
- 38m (41yd) of Appleton 206 (or DMC 7165)
- 47m (51yd) of Appleton 204 (or DMC 7215)
- 23m (25yd) of Appleton 765 (or DMC 7845)
- 32m (35yd) of Appleton 208 (or DMC 7447)
- 15m (16yd) of Appleton 866 (or DMC 7920)
- 18m (19yd) of Appleton 478 (or DMC 7401)
- 19m (20yd) of Appleton 861 (or DMC 7917)
- 10m (11yd) of Appleton 504 (or DMC 7108)
- 22m (24yd) of Appleton 224 (or DMC 7196)
- 23m (25yd) of Appleton 128 (or DMC 7449)
- 32m (35yd) of Appleton 932 (or DMC 7234)

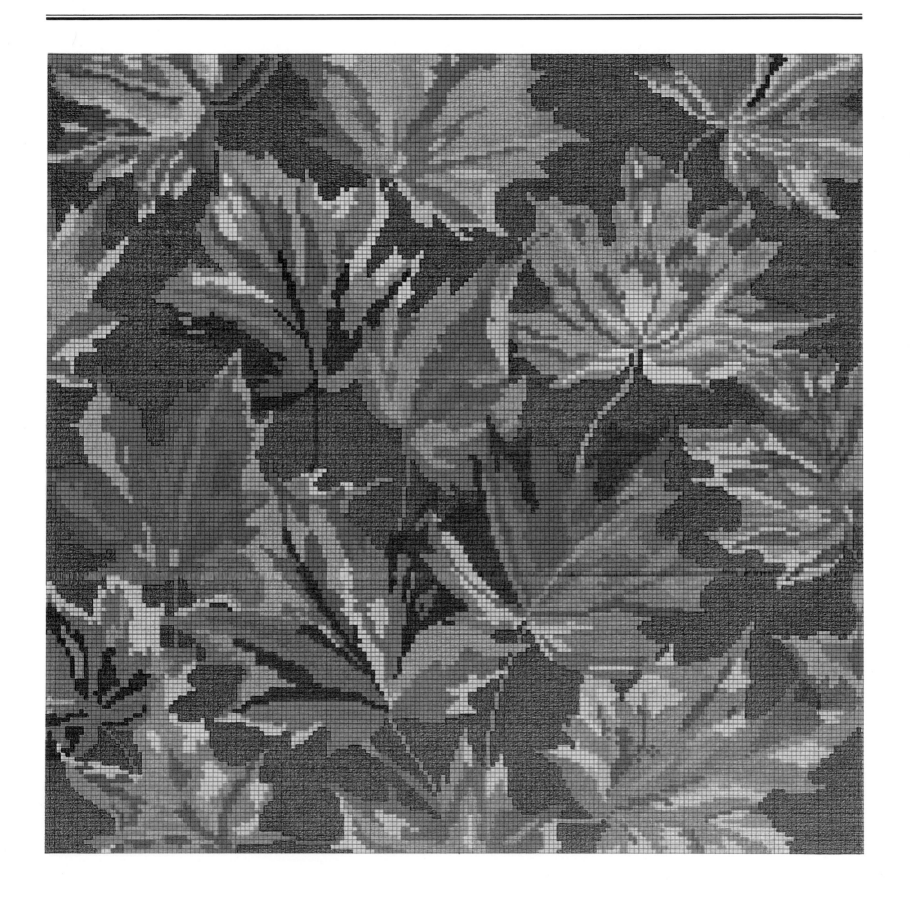

Tulips, *watercolour by Alexander Marshall* (above), *1682, at the British Museum. Little is known about Alexander Marshall except that he was clearly a talented flower painter. Tulips were among his favourite subjects and he recorded several striped varieties in his album of watercolours in the Royal Library at Windsor and in a set of his drawings in the British Museum.*

It was common for patrons of the time to commission flower paintings of this sort. They were pictorial records of favourite flowers and of new species being introduced from abroad. Marshall lived for a time in France where he may have met Nicolas Robert, the finest botanical artist of his day.

'Begonias Hanging' by Jill Gordon (opposite page).

Throughout this century there has been a sporadic interest in natural dyes. They appear softer than chemical ones and there is no doubt that you can tell them apart. None of the designers we work with, however, feel a need to be restricted to these limited shade ranges. William Morris's experiments with dyes were experiments with natural dyes. He needed blue, red, yellow and brown which are the four basic colours necessary for dyeing. He got Kermes, a red dye made from the bodies of insects in Greece; he boiled poplar and osier twigs to obtain yellow; brown came from the roots of the walnut tree and blue from indigo. His passion for natural dyes became obsessive. He wrote in the catalogue for the Arts and Crafts Exhibition Society of 1889 that 'There is an absolute divorce between the commercial process and the art of dyeing so that anyone wanting to produce dyed textiles of any artistic quality in them must entirely forego the modern and commercial methods in favour of those which are as old as Pliny, who speaks of them as being old in his time.' This is a lot of nonsense! No artist should ever be circumscribed by choice of materials but should employ whatever he has at his disposal as seems appropriate. In fairness, the choice of chemical dyes in Morris's day was limited and probably fairly crude, but this is no longer the case. The more colours that are available the better, and needleworkers who stitch their own designs can happily mix shade ranges. There is a difference in weight and texture between Appleton's and Anchor's tapestry wool, for example, but not a significant one. If you are short of a colour in one range borrow it, if you can, from another. It will do no harm to the texture of the completed tapestry and designers will often use wools from a variety of suppliers in the same tapestry. We cannot do this in our kits as their assembly would be too complicated but, for those working their own tapestries, such inhibitions should be abandoned. It is, of course, particularly helpful for shading to be able to extend your colour range in this way.

For most of this century fine art has driven itself further and further into a reductionist cul-de-sac. Painting, which has always been a balance of the metaphysical and the visual, lost its way. It became concerned almost exclusively with theory. Art reflects society in any age so we should not be too surprised that, in the century which created political 'isms', we should also see the emergence of 'isms' in architecture, art and design. The grand visions of political engineering, most notably Communism and Fascism, are discredited and the mental infrastructure which supported totalitarian thought is crumbling. A liberation from the iron rule of the commissars of artistic theory is also well underway. Colour is blossoming and is being used with an intoxicating sense of rediscovery by the new generation of contemporary painters. Paintings no longer need to be 'explained', and representational form is very much in style. This all bodes well for the decorative arts and, in particular, the textile arts. Colour and pattern play a particularly important role in this field. Nearly all the illustrations of textiles, of one sort or another, in this book are rich in both and it is refreshing that, in this new artistic climate, there is no sense of shame in enjoying them. In the British art colleges of the 1960s or 1970s to express an interest in representational art was almost like admitting a sympathy for capitalism in Stalin's Russia. True, the art college élite always represented a praetorian guard in this propagation of art theory and few took this endless prattle about concepts too seriously, but it engendered an atmosphere of mild intimidation for those concerned with such unfashionable artistic subjects as nature and colour. Thankfully that dreary ideological era is now behind us and this is reflected in the exuberant work of so many of the designers featured in this book. An unbridled 'sensuous and emotional' enjoyment of colours is in evidence, and a rediscovery of nature's infinitely subtle colour combinations is in progress. Jill Gordon's 'Begonias' (opposite) illustrates this well. It is a closely observed and detailed study of natural colours. She has taken the colours of the leaves as her starting point and extended them into the fabric background and surrounding area. The hanging is worked in long stitch, like Elian McCready's 'Pansies' in chapter 4, and both of these hangings manage to

blend the close shades of the wools together with great skill, considering the scale of the stitching. The tapestry within a tapestry and the complex colours of leaves build pattern on pattern to create one of the richest and most successful of Jill Gordon's designs.

Candace Bahouth's 'Anjou' has been mentioned before in connection with her use of fuzzy, bargello-style background. These backgrounds are another example of using colour shading in a quite different way. In this case, only two shades of red are employed but by drifting them into each other in a random, asymmetrical manner the background looks mottled, worn and aged. It, in turn, softens the colours of the flowers to create, with that one simple twist, a tapestry with the illusion of gradual shading. And that brings us almost back to where we started. Subtle colour shading was the key to the designs in the first chapter which caught the faded look of old textiles by copying the bleached, soft colours of the originals. This theme resurfaced in other ways in all the succeeding chapters. None of our kits, however elegant the pattern, however well drawn the composition, would succeed without the appropriate use of colour, and the appropriate use of colour for most tapestries is blended and soft. I find it fascinating to speculate how much further we can take this process with printed canvases for kits. We may have gone as far as we should without driving our customers completely up the wall with so many changes of colour demanded in such small areas. Yet we are now technically able to produce far more complex designs than we thought possible even twelve years ago and this has greatly extended the creative possibilities for the designers we work with.

Since the Middle Ages, the Western delight in nature and in depicting it in artistic form has reflected an awareness of the natural world we live in. Before that, the importance of human values to Greeks, Romans and the world of Antiquity meant that the concept of nature had played a subordinate role. Nature in the past was dangerous and mysterious; it was held in awe but was progressively tamed. A contemporary critic of Rousseau's in the eighteenth

'Anjou' by Candace Bahouth (right), *another of her cushions inspired by the millefleurs backgrounds of medieval woven tapestries. For this one she chose the rather unusual warm strawberry-pink background from the series* the Lady and the Unicorn *at the Cluny Museum in Paris. A series of six hangings depict a lady in rich costume and jewels performing various different tasks on a ground richly covered with flowers, among which various animals play. Unicorns and lions feature in most panels supporting standards with coats of arms. The series is suffused with an atmosphere of romance and mystery. They were woven, most probably in Tournai, in 1460 and are remarkably well preserved. Candace manages to capture the faded rose colour of the background by blending two shades of deep pink to create a dappled effect. This cushion design has a casual, almost unstructured feel to it which I like.*

century commented sourly that he might have a less benign view of nature if he lived in the jungles of Borneo. It was with the dawn of a more settled society in the West during the Middle Ages that plant forms, flowers and fruits were seen not only as delightful objects in themselves but as prototypes of the divine. In the thirteenth century leafy ornament gradually appeared, carved in wood and stone, and in the margins of manuscripts, and the next stage was towards landscape painting and the use of natural motifs for pattern. From then on we never looked back and in all branches of the decorative arts the shapes and patterns of nature took over. This tradition is, once again, dominant. Floral and natural decoration is everywhere in evidence as we move towards the next century.

We are no longer mesmerised by the advance of science, are less impressed by technological progress, and no longer see mechanisation and nature as somehow in conflict. Probably the most important theme, the strongest inspiration for all fields of the arts over the last century has been scientific and technological progress and its impact on humankind. No longer. Modern industrialised countries have limited space

and expanding populations and it has dawned on us all that we must use our technology to preserve our natural surroundings, or what is left of them. For the first time in human history we do not have to worry about conquering nature, making order out of chaos, but about reviving it. These broad trends of human thinking indirectly affect the world of the arts, and as a respect for the natural world is rekindled so a respect for the beauty of nature is re-established. Natural forms and colours are once again studied by designers, as are the patterns and colours of the past. Against this sympathetic background tapestry designers are particularly fortunate. Their craft is a perfect medium for interpreting the wonders of the natural world, both its shapes and its colours. I am sure we will see a further blossoming of such tapestry design in the next few years and let us hope that the tapestries in this book are just a foretaste of what is to come. I wrote in the introduction that nature is a literally never-ending source of inspiration to all embroiderers and textile designers. It has been so for many centuries and I can think of no conceivable reason why it should not continue to be so for many centuries to come.

Pansies and Daisies by Henri Fantin-Latour (right) at the Ashmolean Museum, Oxford. What a splendid picture to end with. A friend of the Impressionists, in particular Manet, and also of Whistler, Fantin-Latour was himself a traditionalist. His luxurious flower paintings are a pure visual delight.

TECHNIQUES

MATERIALS FOR CANVASWORK

For embroidery on canvas you need only very basic materials: the canvas itself, thread in all the colours of the design and a suitable needle.

CANVAS

Originally the canvas used for this work was made of hemp; in fact, the word 'canvas' is derived from the Greek word for hemp, *kannabis*. Later it was made of linen. Today, the best canvas that is readily available is made of cotton; and in some countries you can find extra-fine canvas made of silk threads. Cheaper synthetic canvas is also available; and there is also a moulded plastic mesh, for small items such as coasters and boxes.

Conventional woven canvas is available in two main types: single-thread, or mono, and double-thread, or Penelope. Single-thread is the more commonly used; it is suitable for any stitch and easy to work on because of the clarity of the mesh. Ordinary single canvas has a simple over-and-under weave, which has a tendency to become distorted through handling. This can be prevented to a great extent by using a frame, and it can also be corrected during the blocking process. Some stitches, such as basketweave tent and cross stitch, distort the canvas less than others, such as continental tent stitch.

A special kind of mono canvas, called interlock, is more stable. Its lengthwise threads are really double threads twisted tightly together; they hold the cross threads firmly, reducing distortion.

In double-thread canvas, pairs of threads are woven together to produce an extra-firm fabric. This firmer construction permits you to jump from one part of the design to another; where the areas of stitching meet the joins will be imperceptible. By pushing the double threads apart gently with the needle, you can work areas of fine detail with four times as many stitches as when working over the double threads.

Canvas comes in a wide range of sizes, referred to as the 'mesh'; or 'gauge'. These have not yet been metricated: 14-mesh (or gauge) and 16-mesh, for example, refer to canvas having 14 and 16 holes (or threads) per inch. For cushions, belts and chairseats the most frequently used mesh is 10 to 14; for smaller items, such as evening bags, 16- or 18-mesh is suitable. For rugs, a double-thread rug canvas with 7 or even 5 holes per inch is normally used.

Canvas also comes in a variety of colours, with pastel shades, especially beige, being the most common. Because even with the most careful stitching minute amounts of canvas will show, choose a shade suitable for the colours in the design. Always buy good-quality canvas. Avoid any knots or thin spots; it may damage the embroidery threads and will not wear well.

THREADS

The threads most often used are made of pure wool and are spun specially for embroidery, being less stretchy than knitting yarns.

Tapestry (or tapisserie) wool is a smooth, four-ply yarn. Used in a single strand it is suitable for medium mesh (10-14 holes) canvas. Some brands are slightly thicker than others.

Crewel wool is a thin, two-ply yarn generally used with two or more strands in the needle. Being soft and fine (yet strong), it blends smoothly. Two or three colours can be used together in the needle for subtle shading.

Persian wool is another two-ply yarn, somewhat thicker than crewel. It comes in a triple strand, which can easily be separated to give one or two strands as required.

For a glossy effect cotton thread can be used. A single strand of no. 3 perlé cotton works well on 16-mesh canvas; no. 5 on 18-mesh. A small amount of a cotton thread can provide an attractive accent in an area stitched mainly in wool.

Tapestry wool has been specified for the projects in this book. However, you can usually substitute crewel or Persian wool if you prefer. The shade numbers for Appleton's crewel are the same as for their tapestry yarn. Close equivalent shades have been suggested in DMC tapestry yarn.

You will need to calculate the amounts of the substitute yarn yourself, basing these on the supplied lengths of tapestry yarn.

CREWEL YARN

One hank of Appleton's crewel wool contains 190m (209yd); a skein contains 30m (33yd). The first step in converting from tapestry to crewel yarn is to multiply the length given for the tapestry yarn by the number of strands required of crewel. For example, if you need 121m (132yd) of tapestry and three times the number of strands of crewel, the total length required is 363m (396yd). Divide this total by the amount in a hank to get the number of hanks you will need: 363m (396yd) ÷190m (209yd)=1.9 (1.89), or 2 hanks. If the total length of crewel required is considerably less than the amount in a hank, divide it by the amount in a skein to get the number of skeins required. However, hanks are more economical and easier to use, so it will be worthwhile buying a hank unless the required amount is only one or two skeins.

PERSIAN YARN

One skein of Paterna Persian yarn contains 7.4m (8yd); however, the strands are treble, so the true length is 22.2m (24yd). If two strands of Persian yarn can be substituted for one of tapestry, the required length given for tapestry must first be

doubled. For example, 121m (132yd) of tapestry will equal 242m (264yd) of Persian. Divide this figure by the amount in a skein to get the number of skeins you will need: 242m (264yd)÷22.2m (24yd)=10.9 (11), or 11 skeins.

In some places you can buy Persian yarn by the 85cm (34 inches) strand, with a total length of 255cm (102 inches). First multiply the number of metres or yards required by 100 or 36, respectively, to get the total length in centimetres (inches), then divide by 255cm (102 inches) to get the number of treble strands required. *Note* The yarn amounts given in this book have deliberately been rounded up slightly, to allow for individual variation in tension and the occasional mistake. It is far better to have a little yarn left over than to run out.

NEEDLES

A tapestry needle has a blunt end which slips easily through the canvas mesh without snagging. Needles come in a wide range of sizes; the higher the number, the finer the needle. For 10- to 14-mesh canvas, a size 18 needle is most suitable.

FRAMES

It is quite possible to do good work without a frame, provided you stitch with an even tension. However, certain stitches will distort the work, no matter how skilled the embroiderer. A frame will help to keep the canvas threads properly aligned, and reduce the correction required in the blocking. It will also prevent your over-handling the work and so keep it cleaner.

A ring-type frame cannot be used, as the canvas is too thick to fit between the two rings, but a stretcher frame – the kind used to support the canvas of oil paintings – is perfectly suitable. The stretchers, strips of moulding with mitred corners, are available from art supply shops and come in many different lengths. Buy two each of the required length and width of your canvas and assemble the frame by slotting the corner edges together. Remember that the design must fit within the *inner* edges of the frame, so buy the stretchers according to the measurement on the inner edge.

The method of mounting a canvas on a stretcher frame is shown on page 115. A more sophisticated frame, the adjustable scroll frame, is expensive but can accommodate various sizes of canvas.

OTHER EQUIPMENT

You will need two pairs of scissors: large dressmaking shears for cutting the canvas and small embroidery scissors for cutting threads. Tweezers are useful for removing mistakes. You may also want a needle-threader and a thimble.

TRANSFERRING THE DESIGN

If you have purchased a tapestry kit, you will find that the design will normally have been printed onto the canvas in colours matching or nearly matching the threads to be used. All you have to do is the stitching.

Designs given in books and magazines may be in the form of a chart or in the form of a drawing or painting to be traced onto the canvas.

FOLLOWING A CHART

There are basically two kinds of chart used for canvaswork designs: box charts and line charts. On a box chart (the kind used in this book) each square represents one canvas mesh or intersection. This type of chart is most appropriate for designs worked entirely in tent or half-cross stitch (see page 116); in such cases the squares can be thought of as representing individual stitches. As on a line chart, the thread colours can be indicated either by symbols or by actual colours.

A design given in chart form can easily be varied in scale by choosing a larger- or smaller-mesh canvas.

ENLARGING A DESIGN

In some books you may find a design that needs to be traced onto the canvas. If it needs to be enlarged first, it will usually be printed with a grid superimposed on it. All you have to do is draw a grid containing the same number of squares as the grid covering the design, but making the squares the appropriate size. Now copy the design freehand, using the lines of the grid as guides to positioning the various parts of the design.

You can easily enlarge any motif or drawing to a size of your own choosing. First trace the design from the original and draw a grid to cover it.

Draw a diagonal line from the lower left through the upper right corner of the tracing to create the enlarged outline as shown. Remove the

tracing, construct the new grid, and copy the design as described below.

TRACING THE DESIGN ONTO CANVAS

Tape the canvas to the design, or hold it in place with weights. With a waterproof pen specially made for marking canvas (available from needlework shops), trace the four edges of the design, running the pen along the groove between two canvas threads. Then trace the design itself. Follow any curved or diagonal lines freely; don't attempt to follow the grid of the canvas.

Allow the ink to dry thoroughly for several hours before beginning to stitch.

If you like, you can paint the colours onto the canvas, as is done for most hand-painted kits. Do not use watercolours, as these will run during the blocking process; even acrylics sometimes run, so avoid these, too. Use oil paints in a few basic colours, and mix these to get the required shades. Add a little turpentine and mix well. Test the consistency on some spare canvas; the colour should be bright and the paint just enough so that it doesn't clog the canvas mesh. The paint may take two or three days to dry.

PREPARING THE CANVAS

Cut the canvas 4-5cm (2 inches) larger all round than the size of the finished work. Bind the edges

with masking tape to prevent them from unravelling, or machine stitch lengths of seam binding over the edges.

Place the canvas on a piece of sturdy paper, such as blotting paper, and draw round the edges with a pencil. Keep this outline for use later when blocking the completed canvas.

As you are working from a chart, mark the vertical and horizontal centres of the canvas. The chart's centre should be marked with a cross. If this cross lies between stitches, mark the canvas between two threads either with a waterproof canvas-marking pen or with tacking (basting). If the centre of the chart runs along a line of stitches, run the pen straight along a canvas thread at the vertical and horizontal centres. Begin stitching at the centre point of the design.

MOUNTING THE CANVAS ON A STRETCHER FRAME

Once the design has been transferred, or the centre marked, the canvas may be mounted onto a frame.

Unless you are going to be undertaking a great deal of canvaswork of different sizes, a stretcher

frame is perfectly suitable. You will need to buy four stretchers, two each of the required length and width for your canvas.

To mount your prepared canvas, first mark the centre point on each side of the frame, and on each side of the canvas. Match the centre mark of the top edge of the canvas to the corresponding mark on the frame, and fix it in place with drawing pins (thumbtacks).

Working outwards to the edges, fasten the top edge of the canvas to the frame, placing the pins (tacks) about 2cm (¾ inches) apart. Repeat along the bottom edge, pulling the canvas taut.

When fastening the side edges, begin by fixing the centre points as before, then work on one side, then the other, from the centre edges, placing each pin (tack) opposite the other in tandem. This way you will be able to pull the canvas as taut as you can while distorting the weave as little as possible.

A scroll frame is a slightly more complex piece of equipment, but it has the advantage of being adjustable, which means that it is suitable for canvases of varying sizes. Instead of being attached directly to the frame itself, the canvas edges are sew to the webbing on the horizontal rollers; then laced to the side laths, which will have pegs or screws for adjusting the dimensions and ensuring a good taut canvas to work on.

TO BLOCK A PIECE OF CANVASWORK

When all the stitching is complete, the piece of embroidery must first be blocked, or stretched, before it is made up into the finished article. Even if it has been worked on a frame and is not distorted, it will look fresher after blocking; and if it has been pulled out of shape, blocking is essential.

You will need a piece of plywood or hardwood at least 5cm (2 inches) larger all around than the work, a hammer, carpet tacks and the piece of blotting paper on which you have previously drawn the outline of the canvas. (If you have neglected to do this, draw a rectangle using two adjacent sides of the canvas as a guide to the measurements.)

Hold the work up to a strong light to make sure that no stitches are missing. Trim the thread ends closely on the wrong side. Clip the selvedge, if

any, at short intervals; do not remove the masking tape or seam binding.

Tape the blotting paper to the board, and place the embroidery, wrong side up, on the board (first moisten it slightly if it is badly distorted). Tack it to the drawn outline at each corner. Continue tacking along all four sides, inserting the tacks at intervals of about 2cm (¾ inch).

Dampen the work thoroughly, using either a sponge or a spray bottle. For most types of work you should now leave it to dry thoroughly – this may take several days for something as large and thick as a rug. But in certain circumstances the canvas should be removed from the board while still damp, in which case instructions for this will be given under the individual design.

BASIC STITCHING TECHNIQUES

To start work, make a knot in the thread, and take the needle from the right side to the wrong side, a short distance ahead of the starting point. Bring the thread up at the starting point, then stitch until you reach the knot, which you can then cut off. To end the work, take the needle through the under-

side of a few stitches, then cut off the tail end of the yarn. A new thread can also be fastened by taking it through the wrong side of the stitches.

Canvas embroidery can be worked with either a 'sewing' or a 'stabbing' movement – unless, of course, the work is framed, in which case the stabbing movement must be used.

If you are left-handed, you may wish to reverse the direction of working shown in these diagrams. If you use the stabbing technique, you should be able to work comfortably in any direction; otherwise you will need to rotate the work in order to sew from right to left where necessary.

Avoid using too long a thread. About 50cm (20 inches) is the recommended maximum length. If the yarn becomes untwisted or kinks up, allow the needle to hang freely, and the yarn will resume its natural twist.

As a general rule, avoid bringing the needle up through a hole already partially filled with yarn. The needle will tend to split the strands, producing an untidy effect. Working down into the hole smooths the fibres and makes the stitches more clearly defined.

STITCHES

There are many canvaswork stitches, but by far the most popular is continental tent stitch, which is also called petit point. This is worked over a single canvas thread intersection and is thus capable of depicting fine detail and subtle shading.

There are two forms of what might be called 'orthodox' tent stitch: continental tent stitch and basketweave tent stitch. Both of these produce a very firm fabric.

Half-cross stitch is virtually indistinguishable from basketweave and continental on the right side, but the resulting fabric is not so hard-wearing. It is probably the best method for a beginner.

TENT STITCH (CONTINENTAL)
This stitch, which covers one mesh of the canvas, may be worked either horizontally or vertically. It is best to fasten off the thread at the end of a row, or take it through to the underside of the work, and work all rows in the same direction, rather than rotating the canvas on alternate rows, which would entail bringing up the needle through a pre-

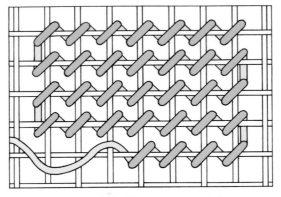

viously worked stitch. Because this stitch tends to distort the canvas, it should be worked on a frame.

TENT STITCH (BASKETWEAVE)
This version of tent stitch is worked diagonally. It has two main advantages over continental stitch: it

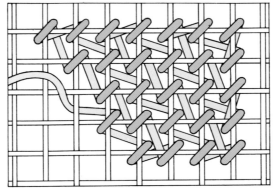

hardly distorts the canvas at all, and rows are worked back and forth, without having to turn the canvas or fasten off the thread. It also uses slightly less thread and is ideal for backgrounds.

HALF-CROSS STITCH
This stitch appears virtually identical to tent stitch on the right side, but covers only the horizontal

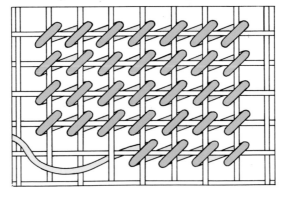

thread of the canvas on the back. This makes it more economical on yarn but less firm. It is worked in rows, either horizontally or vertically. Take care not to pull the yarn too tightly. Half-cross must be worked on either interlock or double-thread canvas. Worked on single canvas, the stitches slip under the vertical thread. Half-cross can be worked back and forth; because the work is less dense than continental tent, the previously worked stitch is less likely to be disturbed.

MAKING UP A SIMPLE CUSHION COVER

The inner cushion used should be the same size as the cover, or perhaps a little larger; this will ensure a good, plump fit, especially at the corners, which tend to wrinkle if a smaller pad (pillow form) is used.

The simplest way of making up a cushion is to place the embroidery and the backing fabric together with right sides facing, and stitch around three sides and part of the fourth, leaving a gap just large enough for inserting the pad. Then turn the cover right side out, insert the pad, and slip-stitch the canvas edges together.

INSERTING A ZIP FASTENER
If you wish the cover to be removable, you can insert a zip in the backing fabric.

Cut two pieces of backing fabric, making each piece the height of the finished cover and half the width, plus 2cm (¾ inch) seam allowance on all edges.

Pin the two pieces together (with right sides facing) along one vertical edge. Stitch at either end, taking a 2cm (¾ inch) seam allowance and leaving a gap 2cm (¾ inch) longer than the zip; then tack (baste) with small stitches (or the longest machine stitch) along the zip opening. Press the seam open.

Turn under and press 5mm (¼ inch) on the seam allowance of one piece. Place this along the edge of the zip as shown, with the slider 1.5cm (½ inch) below the top of the tacking, the pull tab extended, and all the fabric lying to the right. Pin and tack (baste) through the fold of fabric and zip.

Stitch by machine, using a zipper foot, or by hand, using a small, spaced backstitch, close to the edge of the fold.

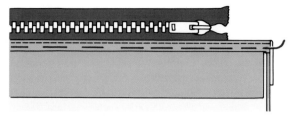

Place the fabric right side up and opened out, with the zip lying flat underneath and with the pull tab turned down. Pin and tack (baste) along the remaining edges of the zip, through all layers. Stitch by hand using backstitch, or by machine. Remove all tacking (basting), including the stitches holding the opening together.

When making up the cover, open the zip first and stitch around all four edges. Turn the cover right side out through the zip opening then insert the cushion pad (pillow form).

PIPING

A piped edge gives a cushion a professional-looking finish and is well worth the small amount of extra work.

Buy enough piping cord to go around the edges of the cushion, plus a little extra for joining. The fabric used is normally the same as that used for the back of the cushion. Avoid very thick fabrics and those that fray easily. For best results the strips should be cut on the bias (at a 45-degree angle to the selvedge).

Cut strips of fabric, making the width equal to the circumference of the piping cord plus twice the

seam allowance. Join strips, if necessary, on the straight grain, as shown above.

Wrap the strip around the cord, right side outside, and machine stitch close to the cord, using a zipper foot.

Pin then tack (baste) the piping to the back of the cushion cover, placing the cord inside the seamline, so that the seam allowances lie towards the edge. Clip the piping seam allowances at the corners to make them lie flat.

If the piping is narrow, the ends may simply be overlapped and tapered into the seam. If the piping is thick, end the tacking (basting) about 5cm (2 inches) to either side of the chosen joining point and unpick the stitching for the same distance. Join the fabric ends on the straight grain as described above; trim and press the seam. Cut the cord so that the ends overlap by 2-3cm (about 1 inch). Cut away two strands from one end and one from the other; wind the remaining strands together and bind them with thread. Fold the fabric over the cord and tack (baste) it in place.

Stitch the piping in place, just outside the seamline. Tack (baste) the back of the cover over the front, right sides facing, enclosing the piping. Stitch it in place, using the zipper foot, working as close as possible to the cord. Leave a gap for turning, unless a zip fastener has been inserted in the back.

MOUNTING EMBROIDERY FOR A PANEL

The method described here can be used for a panel (which should then be framed professionally) or for any other flat object, such as a box lid. You will need a piece of thick, acid-free cardboard or hardboard slightly larger (if for a panel) than the finished work. If the margin is to fit under the rebate of a frame moulding, it is best to select the moulding and measure the depth of the rebate before cutting the board. If in doubt, make the margin scant, as an overlap is obviously preferable to a line of unworked canvas. You will also need some large pins and strong thread.

Place the work right side down, and lay the board on top of it. Fold down one long edge of the canvas and pin it to the edge of the board at short intervals. leaving the required margin on the right side of the work. Repeat on the other long edge.

Thread a large needle with the strong thread, without cutting it from the reel (spool). Starting at the centre, lace the two edges together as shown, working through them alternately. Fasten the thread at one end. Cut off a generous length from the reel, and work to the opposite end. Before fastening off, pull the stitches firmly along the whole length to make sure the work is taut, and check that the margins of unworked canvas are equal. Fasten off and remove the panel pins or thumbtacks.

Repeat the lacing process on the remaining edges, folding the corner neatly.

Alternatively, the completed embroidery can be mounted on an artist's stretcher frame, as described on page 115.

YARN AND KIT INFORMATION

For the designs charted in this book it is best, although not essential, to use the yarns specified. Quantities have been calculated to allow for either half-cross, tent or basketweave stitch. As a result those using half-cross stitch will err on the generous side. This is preferable to have readers running out of colours and, as no two stitches use exactly the same tension, quantities have purposely been estimated to allow room for this, and for wastage caused by mistakes. The yarns used in the canvaswork instructions given in this book – Anchor, Appleton, DMC and Paterna – are widely available in needlework shops. For information on your local stockist and mail-order sources contact the addresses below. All of the designs in the book are available as kits from Ehrman.

TAPESTRY WOOLS

Anchor Tapisserie:
Coats Paton Leisure Crafts Group, McMullen Road, Darlington, County Durham DL1 1YQ, England. Tel: (0325) 381010.
Susan Bates Inc., P.O. Box E, Route 9A, 212 Middlesex Avenue, Chester, Connecticut 06412, U.S.A. Tel: (203) 526 5381.

Appleton Bros. Ltd.:
Thames Works, Church Street, Chiswick, London W4 2PE, England. Tel: (081) 994 0711.

American Creweland Canvas Studio, P.O. Box 453, 164 Canal Street, Canastota, NY 13032, U.S.A. Tel: (315) 697 3759.

DMC Creative World:
Pullman Road, Wigston, Leicester LE8 2PY, England. Tel: 0533 813 919.

DMC Corporation, Port Kearny Building # 10, South Kearny, New Jersey 07032-0650, U.S.A. Tel: (201) 589 0606

Paterna Ltd.:
P.O. Box 1, Ossett, West Yorkshire WF5 9SA, England. Tel: (0924) 276744.

EHRMAN

U.K.: Ehrman, 14-16 Lancer Square, Kensington Church Street, London W8 4EP, England. Tel: (071) 937 8123.

OVERSEAS DISTRIBUTORS
U.S.A.: Ehrman, 5 Northern Boulevard, Amherst, New Hampshire 03031.
Tel: 800 433 7899.

Canada: Pointers, 1017 Mount Pleasant Road, Toronto, Ontario M4P 2MI. Tel: 416 322 9461.

Australia: Sunspun Enterprises Pty, 191 Canterbury Road, Canterbury, 3126 Victoria. Tel: 3 830 1609.

New Zealand: Quality Handcrafts, P.O. Box 1486, Auckland.

France: Armada, Collonge, Lournand, Cluny 71250. Tel: 85 59 1356.

Italy: Sybilla, Via Rizzoli 7, 40125 Bologna. Tel: 051 750 875.

Sweden: Eva Wincent Gelinder, Wincet, Luntmakargatan 56, 113 58 Stockholm. Tel: 08 673 70 60.

Finland: Novita, Helsingfars Yllespinneri AB, Murbacksgatan 2C, 00210 Helsingfars, Finland. Tel: 80 673179.

EHRMAN KITS

All of the canvaswork embroideries featured in this book are available as kits. The dimensions and the canvas mesh size for each embroidery are given with the instructions for each design. All of the kits are suitable as cushions or pictures unless otherwise stated. To order kits either contact Ehrman (addresses above) or fill in the order form (U.K. only).

BIBLIOGRAPHY

Landscape into Art, Kenneth Clark, John Murray, 1976

Romantic Art, William Vaughan, Thames & Hudson, 1978

The Story of Art, E. H. Gombrich, Phaidon, 1950

The Formation of Islamic Art, Oleg Grabar, Yale University Press, 1973

European Flower Painters, Peter Mitchell, A & C Black, 1973

A History of Tapestry, W. G. Thomson, E.P. Publishing Ltd, 1973

Oriental Rugs, Ian Bennett, Oriental Textile Press, 1981

A World of Embroidery, Mary Gostelow, Mills & Boon, 1975

A History of Textile Art, Agnes Geijer, Sotheby Parke Bernet Publications, 1979

William Morris By Himself, Gillian Naylor, Macdonald & Co, 1988

Textile Art, Michel Thomas, Weidenfeld & Nicolson, 1985

Wallpaper, A History, Françoise Teynac, Thames & Hudson, 1982

English Interior Decoration 1500-1830, Margaret Jourdain, Batsford, 1950

Flowers in Art from East and West, Paul Hulton and Lawrence Smith, British Museum Publications, 1979

The New Encyclopedia of Textiles, Prentice Hall, 1980

The Embroiderers' Garden, Thomasina Beck, David & Charles, 1988

History of Colour in Painting, Faber Birren, Reinhold Publishing Corporation, 1965

Silk Designs of the 18th Century, Natalie Rothstein, Thames & Hudson, 1990

Pattern Design, A Book for Students, Lewis Day, Batsford, 1903

ACKNOWLEDGEMENTS

PHOTO CREDITS

The publishers and author would like to thank the following for permission to use illustrations:

Amon Carter Museum, Fort Worth (acquisition in memory of Katrine Deakins, Trustee, 1961 1985) page 48; Ashmolean Museum, Oxford p. 112; Trustees of the British Museum p. 88, p. 108; © 1978 Estate of Duncan Grant by courtesy of Henrietta Garnett and Paul Roche (photo South Bank Centre) p. 29; The Frick Collection, New York p. 81; Gemaldegalerie Staatliche Museen/ Preussischer Kulturbesitz, Berlin p. 20; John Mitchell & Son p. 66; Musée de Cluny (photo RMN) p. 95; Museum of Fine Arts, Boston (gift of Esther Oldham) p. 30; Nationalmuseum, Stockholm p. 14; Suttons Seeds Ltd p. 68; Trustees of the Victoria and Albert Museum, London p. 19, p. 24, p. 37, p. 42, p. 47, p. 53, p. 100; Trustees of the Wallace Collection p. 38.

LOCATION ACKNOWLEDGEMENTS

With grateful thanks to Georgia Hicks and Cherry Patey for the loan of items from their Antique & Interiors Gallery, Pulborough, Sussex, and the delightful surroundings in which to photograph.

Thanks to Julia Hodgkin at The Flower Shop at Heal's for her help and involvement in our unceasing search for out of season flowers.

Thanks to John Chevallier Guild of Aspel Cider, Debenham, Suffolk, for allowing us to photograph the Apple and Cabbage Carpet on their original 1728 granite press.

I would like to thank the following:

Valerie Buckingham, at Century, who has edited and guided this book from start to finish. Hilary Arnold for having the courage and faith to see it through a recession; and Sarah Wallace, late of Century, for commissioning it and having the idea in the first place.

Rosemary Weller, star of the show, whose photography makes this book. And Fiona Tillett for styling the pictures so well.

Bet Ayer for her meticulous, elegant design.

Colin Salmon who has nobly struggled through the charts. And Sally Harding who has coordinated all their information

Gillian Meakin at William Briggs and Jean Stanley at Readicut who between them have originated all the designs with absolute dedication and an instinctive sympathy for the designers' work.

The small team at Ehrman: Jacqueline, Geraldine and Natasha at the shop, and Sue and Carole at the office who hold it all together.

And, of course, the designers without whom we wouldn't have the book.

INDEX